CW00740418

Struggle and Suffrage
in Norwich

Struggle and Suffrage in Norwich

Gill Blanchard

PEN & SWORD
HISTORY

AN IMPRINT OF PEN & SWORD BOOKS LTD.
YORKSHIRE - PHILADELPHIA

First published in Great Britain in 2020 by
Pen & Sword Military
An imprint of
Pen & Sword Books Limited
Yorkshire - Philadelphia

Copyright © Gill Blanchard, 2020

ISBN 978 1 52671 7 610

The right of Gill Blanchard to be identified
as Author of this work has been asserted by her in
accordance with the Copyright, Designs and Patents Act 1988.

A CIP catalogue record for this book is available from the British Library

All rights reserved. No part of this book may be reproduced or
transmitted in any form or by any means, electronic or mechanical
including photocopying, recording or by any information storage and
retrieval system, without permission from the Publisher in writing.

Printed and bound in the UK
by CPI Group (UK) Ltd, Croydon, CR0 4YY

Pen & Sword Books Limited incorporates the imprints of Atlas,
Archaeology, Aviation, Discovery, Family History, Fiction, History, Maritime,
Military, Military Classics, Politics, Select, Transport, True Crime, Air World,
Frontline Publishing, Leo Cooper, Remember When, Seaforth Publishing,
The Praetorian Press, Wharncliffe Local History, Wharncliffe Transport,
Wharncliffe True Crime and White Owl.

For a complete list of Pen & Sword titles please contact
PEN & SWORD BOOKS LIMITED
47 Church Street, Barnsley, South Yorkshire S70 2AS, United Kingdom
E-mail: enquiries@pen-and-sword.co.uk
Website: www.pen-and-sword.co.uk
Or
PEN AND SWORD BOOKS
1950 Lawrence Rd, Havertown, PA 19083, USA
E-mail: Uspen-and-sword@casematepublishers.com
Website: www.penandswordbooks.com

Contents

Introduction

Women have always played an integral part in shaping the history of Norwich, once the second most important city in England. Sadly, women's voices and experiences still often remain in the shadows, particularly those who are considered 'ordinary'. A photograph of a group of women who lived at Globe Yard off Heigham Street in around 1914 appears on the cover as it encapsulates the theme of struggle and suffrage. The women who lived at this yard during most of the hundred-year period covered here therefore form a loose thread throughout the book, as they typify the lives of the majority of women who were born, lived and worked in the city.

The women of Globe Yard were primarily working class, poor, with limited education, and unlikely to ever make it into history books. Within a couple of generations of this photograph being taken they all had the vote, improved living conditions, expanding work and leisure opportunities and far greater legal rights than their mothers and grandmothers ever knew. While there was still a long way to go when this book ends in 1950, the lives of the women of Norwich had truly been transformed.

Despite many sterling efforts to redress the balance, the tales of radicalism, entrepreneurship, innovation, struggle and social, legal and political reform over the centuries are primarily constructed around the men born and resident here. This book focuses on a hundred-year period between 1850 and 1950. Of course, women's history does not start and end at these points, but it is a period in which some of the most major changes occurred, affecting women's work, education, legal rights, financial independence and opportunities to participate in public life.

Traces still remain of women who made their mark on the city's development, from the notable to the masses whose names have never graced a history book. Among them are Emma Fitzwilliam who held Norwich Castle for three months under siege, in a revolt against the king in 1075; the medieval hermit and mystic, Julian of Norwich, who was the first woman known to have written a book in English, and Margaret Paston, who had a home on Elm Hill in the city and was the matriarch of a family whose letters provide so much fascinating information about domestic life, and local and national politics in the fifteenth and early sixteenth centuries. There were others, such as the 'virgins of Norwich' who raised £140 to fund a parliamentary regiment known as the Maidens Troop during the English civil wars.

Norwich has also been home to a host of female writers, artists, musicians, scientists, reformers and businesswomen. They include Mary Chapman (née Mann) who was born in 1647 and who founded the Bethel Hospital, the first purpose-built asylum in the country, to cater for the welfare of the mentally ill. There was also the prison reformer Elizabeth Fry and authoress and reformer Harriet Martineau, who were both born in the same house off Magdalen Street. Elizabeth Fry died five years before the start of the time period this book focuses on, yet her legacy on women's lives for generations afterwards cannot be underestimated. While she is best known for her work in improving conditions in women's prisons, she also campaigned for the same in workhouses and helped to set up District Visiting Societies to work with the poor, a Maternal Society, and a Society of Nursing Sisters, which was the first training school for nurses.

By necessity a book of this size can never include all aspects of women's lives such as music, the arts, and entertainment. There are, therefore, many more stories to tell, such as Anna Sewell, author of Black Beauty, and the women artists Emily Crome, Emma Sillett, Eloise Harriet Stannard, Emily Stannard, Anna Maria Stannard and Emma Sandys. Among them was Catherine Maud Nichols (1847–1923), who lived on Surrey Street. She attended classes at the Norwich School of Art, made her

name with her etchings and was elected to the Royal Society of Etchers in 1882. Catherine also wrote poems, plays and stories, although these were less successful than her artwork.

Other women's contributions to music, the theatrical world and the arts have been forgotten, overlooked, or appear as footnotes in history books. These include Sarah Ann Glover (1786–1867) who was born on Pottergate, who set up a music school at Black Boys Yard and taught at various Norwich institutions, including the workhouse and the institute for the blind. Sarah Ann developed the 'do-re-mi' system of learning musical notes (Sol-fa), which was taken up and developed by John Murwen. Her interests in trying to make it possible for anyone to play music even if they could not read it, led her to research the relationship between colour and music. This led Sarah Ann to invent the glass harmonicon as a means of establishing musical pitch and to train the ear.

Less well known is the anti-vivisectionist and campaigner for animal welfare, Mary Bertholina Mann (known as Bertie). She was also a talented artist whose work was sold at Jarrolds department store, and she took commissions from the publisher Raphael Tuck. Bertie was also elected as a fellow of the Royal Society of Etchers, and combined her work with actively campaigning to end vivisection and the trade in worn-out horses.

Then there was Margaret Elizabeth Fountaine (1862–1940), who was an adventurer and world-renowned authority on butterflies, who broke many social conventions as she travelled the world and lectured at scientific conventions. Her diaries, which she bequeathed to Norwich Castle Museum along with her butterfly collection when she died, were first read in 1978, revealing the limitations placed on her by society and how she had to conceal her relationship with her companion. Sadly, the focus on her 'scandalous' behaviour has often obscured her scientific contributions.

Standing behind them are even more women whose names never made the history books. Those who ran homes, worked, endured attacks during wartime and cared for the sick. There are many others whose desperate circumstances influenced the

efforts of others to improve the lives of those less well-off than themselves.

All these women's stories are part of the backdrop of the history of Norwich, but a history of women in a book of this size can only skim the surface. Therefore, by focusing on relationships, marriage, housing, poverty, work, education and women's activism in changing the world through social, legal and political reforms, I have tried to give the struggles of women in Norwich a voice.

Acknowledgments

There are many people who have played a part in the writing of this book. Firstly, I would like to thank fellow author Phyllida Scrivens, for her encouragement and support. I would also like to thank Sam Earl for allowing me to use his collection of Norwich Labour Party and Trades Union ephemera; Mike Bristow for the Norwich postcards and a copy of examination papers from Norwich Training College. Tombland Antiquarian Bookshop kindly allowed me to use and reproduce copies of books and ephemera relating to Margaret Pillow, which are part of their stock. I am also very grateful for the kind help of Jonathan Plunkett who supplied me with copies of photographs of Globe Yard taken by his father George Plunkett in 1937.

Tom Greenwood of Norwich High School for Girls generously shared his MA dissertation on the school and the Great War, as well as school magazines. Julie Jakeway also let me use her MA dissertation on Thorpe St Andrew Asylum, which provided much insight into mental health facilities in the city. Paul Cunningham also helpfully sent me material on the Norwich branch of the Women's Co-operative Guild.

Several other people shared memories, memorabilia and their own research; notably Kerry Minns and Phyll Clements. I would also like to thank Norfolk Record Office and Norfolk Heritage Centre for allowing permission to use excerpts and copies of documents and photographs.

Last, but not least, my own personal support team, particularly Norwich Writers' Circle, Ian Buckingham and Pipa Clements, without whom this book would almost certainly not have been completed.

In honour of the women of Norwich in whose footsteps we walk.

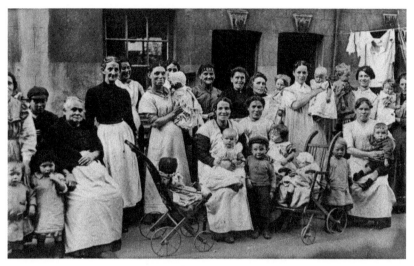

The women of Globe Yard off Heigham Street circa 1914

Education

One day in around 1914, a group of women living at Globe Yard off Heigham Street in Norwich gathered to have their photograph taken with their children. At least half had, to some degree, benefited from the expansion of educational opportunities in the latter half of the nineteenth century. The younger ones were typical of vast numbers of women in the same age range across the city who had experienced the introduction of elementary education in 1870. Yet until 1877, children under 10 could still be employed in factories. Those between the ages of 10 and 12 could still work half-time into the 1900s, as long as their employers provided some schooling.

Several of the women in the photograph were among nineteen adult women aged between 27 and 66 recorded at Globe Yard when the national census to record the population was taken on 2 April 1911. When 23-year-old Eliza Matilda Armes married Albert Swatman in 1900 she signed her name in the marriage register with a firm hand. Eliza and her married sisters, Ellen Wacey and Leah Hunton, who also lived in the same yard in the early 1900s, all had some schooling. In contrast, their 56-year-old mother Rebecca Armes (née Gurney) could only make her mark when she married Frederick in 1869.

Someone making their mark as a measure of literacy does need to be treated with caution, as some people could read but not write, while others may only have been able to sign their name. There is also evidence that some women may not

have shown off the fact that they could write if their husbands could not, as their signature appears on other records, even though they made only a mark when marrying. Nevertheless, the educational experiences of the women living at Globe Yard when the 1911 census was taken reflects those of the vast majority of women across the city (and country).

Although virtually all Norwich women under the age of 40 when the 1911 census was taken were literate to some degree, the majority of those over 20 years of age had left school at the age of 10. Those who attended school after 1891 when the school leaving age was raised could, if they were fortunate, stay on until 13. Rebecca Swatman of Globe Yard was typical as she was recorded on the 1911 census as already working at 13 years old, although her 9-year-old brother and 7-year-old sister were recorded as scholars. While these children, and thousands of others like them in the city, could stay in school for three years longer than most of their parents had, only a tiny percentage were educated past this point, and many still started work at 12, 11 or even 10 years old.

Although the 1870 Education Act ensured that that schools were available in every area it was another ten years before it became compulsory to attend, and even then only up to the age of 10. It took until 1891 before education up to the age of 13 was effectively made free when funding was given by the government of up to ten shillings per child. Although the leaving age was raised to 13 at the same time, it was possible for children to leave school before then by obtaining an exemption certificate that proved they had achieved a certain educational standard. Large numbers of families took advantage of this because of the need for their children to contribute to households' finances by going out to work. The exemption system was only slowly phased out over the next three decades.

Rebecca Armes's inability to write her name when she married in 1869 was not necessarily just due to when she was born. Her neighbour, Sophia Cubitt (née Dallaston), who was just a year younger, had signed her name when she married in 1876. Living in an area where charities or a workplace provided

schooling, and religious background all played a part. Many Nonconformists from all levels of society were at least taught how to read because of a prevailing belief among those groups that everyone should be able to read the Bible for themselves. However, the main factor for the majority of people was lack of money, and the necessity to go out to work as soon as possible.

Before the 1870 Act, large numbers of people did not receive any formal education. Most schools operating before the 1830s were set up by charities or religious organisations, or were fee-paying. In Norwich in 1854 there were nine charity schools with a total of 750 boys and 500 girls. For instance, Revan's Charity paid for six or eight girls every year from the parish of St Martin at Oak to be instructed and clothed at the cost of £11 a year. Needless to say, the quality of education offered was variable.

Another was the Girls' Orphan Home and School which was set up on Pottergate in 1847 for fifteen children, by a group of women Quakers, including the author Amelia Opie. Its aims in the 1890s were to educate destitute orphaned girls of married parents and train them for domestic service, or other means of supporting themselves respectably. It continued to exist until the 1930s. A similar organisation in Heigham accommodated fifty girls aged from 5 to 15. Although the charity schools were funded by subscription, most pupils still had to pay one or two pennies a week. Although a Ragged School was set up in Norwich in 1844 that offered free classes to poor children on Sundays and two evenings a week, it closed in 1857.

The National Schools were established by the National Society for Promoting the Education of the Poor on behalf of the Anglican Church (established 1811). They, and other charities such as the British and Foreign School Society (Nonconformist), received annual parliamentary building grants to build schools from 1833. These eventually led to the formation of an elementary school system across the country. Expanding industrialisation meant that formal and informal educational opportunities through organisations such as the Mechanics' Institute were expanding for men, and women began seeking them out too.

However, education was still out of reach for many of the poorest. In 1840, 60 per cent of women were illiterate. By 1851, only around one in eight of the whole population attended day schools, but by 1860 the rate of illiteracy among women had dropped to 40 per cent. One of the ironies of the union workhouse system introduced in the 1830s, which was usually only resorted to in times of desperation, is that it provided an education and some training to inmates that they might not otherwise have had.

By the mid-1850s there were several National and British schools in different areas of Norwich city. The Colman family were among the many people in trade who became involved in social reform. They saw education as something everyone should have access to and set up a school for the children of their employees at their mustard factory in 1856. Parents paid a penny a week for one child, and a halfpenny for any others, with the money going towards school prizes. By 1870, the school had 324 pupils. Mrs Mary Colman was actively involved with running the school, and the school was the first elementary school in Norwich to teach cookery to children.

During the second half of the nineteenth century it was more widely recognised that women should be educated, if only because they were responsible for instructing their own children when very young. The argument was that if mothers were ignorant, then their children were likely to be so as well. This was as much about moral education as literacy and numeracy. For those girls who did receive an education, the focus was on the basics of reading, writing and arithmetic and domestic skills.

The 1870 Education Act was a watershed moment, particularly for women. England and Wales were divided into school districts, each with elected school boards. These were intended to supplement the existing church schools, not replace them, and their task was to provide elementary schools, known as board schools, where existing facilities were inadequate. Not only did the new Act open up the possibilities for women to be educated, it led to a massive increase in women teachers. Female teachers in the city could train either via the Norwich Training

College (known as the Norwich and Ely Training College from 1892), or the pupil teacher scheme, but whichever route they took there was an increased emphasis on professionalisation. Former students at the training college in the early 1900s recalled how they studied history, reading, English, literature and maths, as well as specialist subjects such as needlework.

The school boards also provided the very first opportunity for women in the UK to be elected to a public office as any adult could stand for election. This was in part because education was widely seen as of particular interest to women due to their maternal natures. Many women relished the opportunity to become actively involved in shaping educational provision, although they were still a minority, and overwhelmingly middle and upper class.

The first women on the Norwich School Board were Charlotte Lucy Bignold (known as Lucy) and Mary Ann Birkbeck, who were both elected in 1881. When they were nominated to stand for the Norwich School Board, the two women were universally praised by the local press, not least because of how they could benefit girls. On 26 October 1881, a reporter for the *Norwich Mercury* suggested that the city could well afford to lose some of the ten men rather than to be without the ladies. He wrote:

> There can be no question that the Board will be the stronger and better adapted for its work if there be lady members. So many questions arise – and more are likely to arise within the next few years – in which the interests and health of girls in public schools are deeply concerned that both sexes should be fully represented on the governing body.

These women, and those who came after them, were from very privileged backgrounds. They also tended to be religious and shared a belief that their position in the world meant they had an obligation to help those less well off. Lucy Bignold was born in 1835 into the family that founded the Norwich Union insurance firm, and spent her whole life living on Surrey Street.

She not only had a passionate belief in the value of education, particularly for girls and women, but was actively involved in her local church and temperance movement, held regular Bible classes at her home and started a probation service for the delinquent.

Throughout Lucy's time on the board she headed campaigns to supply free school dinners for the poorest children in elementary schools in order that their education would not suffer. Although she was a Conservative politically, for the most part this did not prevent her working with the Liberal women to achieve her aims of improving educational opportunities. She pointed out time and time again that hunger was a deterrent to learning. In 1887 and 1888 for instance, she wrote numerous fundraising appeals in order to raise the money in order to provide food grants to the children of the unemployed via their headteachers. The same scheme also arranged penny dinners for poor adults across the city out of six kitchens. Sixteen years later, in the winter of 1904–5 Lucy was still rising to challenge of making sure poor schoolchildren were properly fed. In a letter published in the *Norfolk Chronicle* on 10 December 1904, Lucy wrote:

> The great distress now prevailing in Norwich, owing to a large number of bread-winners being out of work, has suggested to me the desirability of opening kitchens to supply free dinners to as many as possible of the poorest children attending our elementary schools. After consulting the Mayor of Norwich and the Chairman of the Education Committee I have decided to appeal through your columns for money to enable this means of help to be carried into effect. Any money sent to me or paid into Barclay's Bank to 'The Children's Dinner Fund' will be duly acknowledged in the papers. I believe that, with the help of a ladies' committee and the invaluable assistance of the teaching staff, real good may be done.

On 24 December 1904, Lucy's letter of thanks to contributors was published for the £104 9s 6d that had been raised towards the

Children's Dinner Fund ('s' and 'd' being shillings and pence in pre-decimalisation currency). A large number of children were now 'enjoying well cooked and nourishing food, a considerable part of which is prepared by the children attending the elementary schools, under the direction of the cookery teachers employed by the Education Committee'.

One of the regular signatories to the appeals by Lucy for money towards providing meals to poor school children was Charlotte Evans. She was a few years younger than Lucy Bignold and shared a very similar social background as one of eight children of a barrister, who later became Chancellor of Norwich diocese. Charlotte was also very religious, and the scheme to provide free meals in schools to poor children was just one of the many charitable works she involved herself in.

The other woman first elected to the Norwich School Board in 1881 was Mary Ann Birkbeck (1851–1938). She went on to become the first married woman on the board after she wed Samuel Gurney Buxton in 1886. Mary Ann was a pioneer in the development of domestic science teaching in schools in the city, and in creating the first training school for domestic science teachers.

From as soon as she was elected to the Board, Mary Ann actively campaigned for the proper teaching of domestic skills in schools. Against some fierce objections, she was inspired by the example of teaching cookery classes to elementary school girls at the Colman's factory school to persuade the Norwich School Board to implement the first elementary course of cookery classes at St Augustine's Board School in 1884. Those who opposed the idea argued that ratepayers' money was going to be spent on teaching young girls how to create frivolous desserts such as semolina pudding and treacle tart. The critics also argued that such plans were completely inappropriate for working-class girls, and merely showed that was what happened when women were put onto school boards who had no understanding of the lives of such girls, or the financial pressure of having to pay rates.

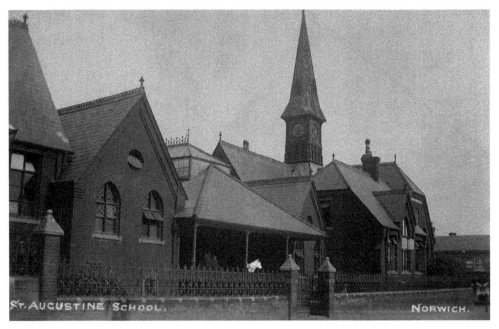

St Augustine's School, 1910

Mary Ann and her committee of women set out to break down the prejudice around the idea that good cookery was an expensive luxury not suitable for a humble palate. They had to demonstrate that the primary recommendation in its favour was the art of rigid economy, and the art of making every scrap of food yield the greatest amount of pleasure and nourishment. It was only half jokingly suggested that Mary Ann's success in convincing them that women learning how to make rissoles, thereby depriving 'cold mutton day' of half its horrors, was an achievement worth investing in.

However, even though they wore down the naysayers, the women's committee was faced with the problem that there were not sufficient teachers skilled enough to teach domestic science. Their solution was to draw up a scheme of teacher training, which was accepted by the Education Department. The result was that the city of Norwich became the first place in the country to set up a training school for cookery teachers.

In 1891, the committee obtained a grant from the county council to occupy a building on St George's Plain and the following year local newspapers reported that: 'The school now accommodates a contingent of girls who "are being indoctrinated with the best domestic principles".' A payment of ten shillings a week was required, with eight of that being paid by the council and the remainder by parents or the local committee. A report in November 1899 described how the school worked in practice:

Gas stoves are used in very hot weather, but are not altogether approved of by Miss H. Deane, the inspectress, though gas stoves are now used in hundreds of homes which the youngsters from which attend Board schools. The utensils too, are identical with the utensils which are in use in the small homes, and so is the food which is prepared. Boiling, frying, baking, stewing, broiling, and steaming are the methods which are taught, some more advanced lessons being given at Duke Street, where the girls have some instruction in the principles underlying cookery, including the chemistry of cooking, the mixing of foods, condiments etc.

Some platform orators are very fond of attacking the Code, but the Code, although of course, it is not perfect, is not nearly so foolish as many persons would have us believe, and in Norwich it has been administered by a committee of ladies, of whom Mrs G. Green and Mrs Pillow have been presidents. The first lesson given to a child the first time she enters the kitchen is how to clean a stove, which ought to be considered sufficiently practical by the most cautious. Then they are taught how to make bread, and home-made bread, it is argued, is at once cheaper and better than that which is bought in the shops. How to make pastry and cakes is then taught, and then plain soups such as pea and lentil, how to make stews, and to dispose of cold meat and fish follow. Many a housewife whose 'man' is a little bit particular in his

feeding would gladly convert the cold dry meat left over, or the cold tasteless bit of fish into rissoles, or fish cakes if she knew how. These things were not taught in her days, though they are to her children.

Mrs Emma Harriet Green (née Prime), or Harriet as she preferred to be known, was the Mrs G. Green referred to. She was an innkeeper's daughter, born in Redenhall with Harleston in south Norfolk in 1852. After moving to the city she worked in a drapers' shop as an assistant. When she was 21, Harriet married George Green, a fellow member of the Baptist Church, who went on to become a city councillor and lord mayor. Harriet and her husband both felt a calling to public service and Harriet devoted six years to the Norwich School Board. She took a particular interest in establishing cookery classes in elementary schools. As a result, her efforts were praised by a correspondent to the local press in September 1893, who noted how she made regular visits to the kitchens and in the process became an honorary inspectress.

Mary Ann Gurney Buxton, as she was after marriage, also worked closely with Margaret Pillow (née Scott), who was elected in 1893. Margaret stood as an Independent Progressive and was the first woman National Union of Teachers (NUT) representative in the region to stand for election to the Board. Margaret was born in Norwich and attended Cambridge University before becoming a teacher, lecturer and headmistress at a range of educational institutions from elementary to teacher training in Norwich and London for over sixteen years. Margaret became the first qualified female sanitary inspector in Great Britain after taking the examinations of the Royal Sanitary Institute. She went on to write books, training manuals and articles on domestic economy, as well as becoming a national inspector of school cookery classes.

Margaret Pillow had been born in Norwich in 1857, and returned to live in the city after her marriage to the county inspector of technical education. When she published a detailed election address to October 1893 to back her campaign, she

went to great lengths to point out her qualifications and wide teaching and lecturing experience. She took a keen interest in the education of girls, advocating the expansion of technical training such as laundry work, which would be of the greatest value to girls after leaving school. Margaret argued that:

> While strictly opposed to any waste or extravagant expenditure of the Ratepayers' Money, I would have due regards to the Heath, Comfort, and General Well-being of the Children by seeing that their work is done in Well Ventilated, Cheerful and Healthy School Buildings, and I would advocate a sufficient and competent Teaching Staff for each school.

She went on to say that she had no political or religious motivation, but simply sought to stand as 'an enthusiastic educationalist'. Margaret spent much of her time on the Board implementing classes in practical cookery. When she stood again in 1896, Margaret said:

> I desire to point out that in a large city with over 14,000 boys and girls in the Boards Schools there is special work for women as Board Members, and that Schoolmistresses, Assistant-Mistresses, and Girl Pupil Teachers, as well as mothers of school girls, are occasionally glad to consult a lady member, to whom they can explain cases of difficulty.

Margaret was a working mother as her children were infants when she was first elected to the school board. Although this was an unpaid position, she continued to write articles and books throughout. However, her claim to be non-political was not strictly true. Her time on the school board coincided with a series of battles between the NUT and the Norwich board over inspections of teachers. She should have been the ideal person to represent all teachers' interests, but, relationships between the female board members, both before and after her election, were sometimes far from sisterly.

Margaret came into direct conflict with Harriet Green, who was the official Progressive Board member, and had spent already three years diligently visiting schools since first elected in 1893. During the election campaign Margaret claimed that the teachers 'were dead against Harriet as she always did what the inspector told her'. Harriet was reassured by a deputation from the Norwich and District Teachers' Association that informed her that this statement was entirely false. Having demanded an apology from Mrs Pillow and not received it, Harriet publicly declared that she could not see how she could comfortably work with her, although she would still do all she could for the teachers. As their disputes over the testing, supervision and pressure on teachers intensified their support divided on gender and political lines, with the male teachers backing Margaret and the women aligning behind Mrs Green. The Women's Liberal Association which included the Colmans, Jarrolds, Jewsons, Mottrams, Copemans and other women from influential Norwich families also supported Mrs Green.

Despite what was described by contemporary observers as unseemly, politically motivated public bickering and unpleasant recriminations, both women were elected. Margaret worked to improve conditions for teachers in particular, but her ability to influence decisions was hampered by having alienated many in the Liberal party, whose representatives were in the majority. Margaret Pillow was voted off the board in 1896 while Harriet Green resigned the same year due to ill health. Her replacement was Mrs Birkbeck, the mother of Mary Ann Gurney Buxton who had been one of the first female Board members to have been elected, and the widow of another former board member.

Margaret Pillow's involvement in education was far from over when she was voted off the board. She continued to support Mary Ann Gurney Buxton, who had been elected to the board a few years earlier than Margaret, in providing and improving domestic science teaching and training teachers in the subject. Despite the previous political conflict between Margaret and some of the school board members she joined Mary Ann's

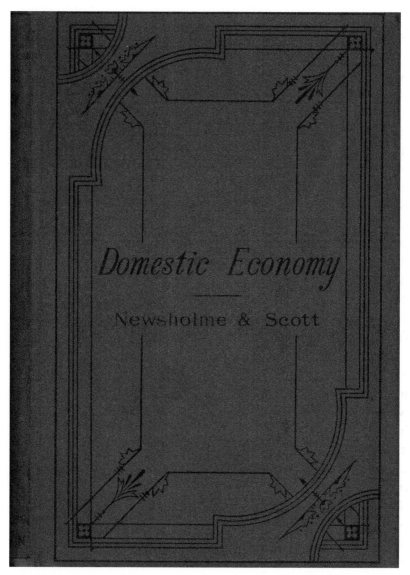

The book on Domestic Economy co-authored by Margaret Pillow

committee and was an examiner in domestic science in Norwich schools as well as inspecting the teacher training schools.

Margaret extended the cookery school idea to providing specialist training for girls who lived in rural areas. By 1900, she was arguing for Schools of Agricultural Economy to be

established for the daughters of 'small farmers and girls above the labouring classes', who were likely to spend their lives in agricultural areas. These could, she suggested, be under the control of the Technical Education Committee. The girls would learn subjects such as poultry rearing, selecting and packing eggs, dairy work, cultivation of small fruits, flowers, salad plants and various vegetables. Such a course might even extend to preserving fruits, jam making, salting pork and curing ham. She appealed to patriotic interests by detailing the amount of butter, fruit and vegetables that was imported each year, and arguing that this could be reduced by the development of these skills.

Sadly, the work of Mary Ann Gurney Buxton, Harriet Green and Margaret Pillow in developing domestic science skills and teacher training is virtually unknown today. Few people are aware that Norwich was the first place in the country to set up a training school for teachers of domestic science and to lead the way in having it recognised as a serious subject worthy of study and investment. It was, of course, aimed only at the girls and the content of educational provision generally continued to be divided into boys and girls subjects well into the second half of the twentieth century. Perhaps it is for this reason that their work in raising the profile of what was generally seen as women's work is why their innovations in the field of domestic science do not get the credit that other educational pioneers do.

There were other women elected to the Norwich School Board until the system was replaced in 1903, including Mrs Mary Ann Burgess who ran a temperance hotel. Altogether, during the Board's lifetime, between a third and half of school managers in Norwich were female, a much higher figure than most other towns and cities. In consequence, those women made a significant contribution towards the accessibility, and types, of education Norwich girls could obtain over the following decades.

Despite the 1870 Act leading to more educational provision, the cost of attending school was still a major barrier for poor families. While the number of children attending school increased after an Act in 1880 made it compulsory for those

up to 13 to attend, it was still not free unless they were fortunate enough to obtain some kind of grant or charitable contribution. As a result, there were many prosecutions of parents for children missing school, as well as for non-payment of fees. When Ellen Green of Crown Yard in the parish of St Martin at Oak was abandoned by her husband in 1879, she had to apply for poor relief. When the guardians of the poor pursued her husband for maintenance, they included school fees for the three children. Caroline Wilkinson of Wood Entry Yard was just one of more than a dozen parents fined at one special court in July 1880 for the adjudication of school board summonses. It cost her six pence, plus four shillings and six pence costs for disobeying a previous order over her child missing school, while the Burmans of Globe Yard had to pay the same for the non-attendance of two of their children.

St Augustine's school in Norwich was one of those founded by local philanthropists and partly funded by the Church of England. It was founded in 1838 and took in pupils from the parishes of St Augustine and St Martin at Oak, as well as the suburb of New Catton. It was expanded following the 1870 Education Act and catered for girls and boys from infants to seniors. The log books for the St Augustine's girls' school reveal that while the majority who joined before the end of the First World War did stay on to 13, significant numbers left a year or two younger, with 'Exempt' written by their names. These children were allowed to leave by obtaining an exemption certificate which confirmed they had reached a required standard, and could therefore leave early. Others simply stopped attending. In 1897 for instance, Ida Hearne of Spencer Street, and Susan Medlow of St Martin at Oak Street were noted in the log books in 1897 as having parents who refused to send them to school. In Susan's case, her mother had kept her home for six months, and after that she only attended irregularly.

Access to higher education was still dominated by public and grammar schools, although some accepted poor pupils via scholarships. There were also evening and adult education classes. The school boards began developing ways to provide a

higher stage of education within the existing elementary system. Some created advanced classes, while others provided separate higher grade schools which began as elementary, but were later recognised as secondary.

The Norwich Higher Grade Schools for boys and girls opened on Duke Street in 1889 to provide a secondary education for working-class children. Due to the efforts of people like George White, who initiated the scheme in Norwich, the idea that girls should have the same access to education as boys became normalised.

Following reorganisation of the educational system at the turn of the century, school boards were abolished in 1902 and replaced by county council education authorities. These were given the power to provide or fund secondary education as well as elementary. There were now two types of state-aided secondary school: the endowed grammar, which receive grant-aid, and the municipal or county secondary schools, which the local authorities maintained themselves. As a result there was a massive expansion of secondary schools before the First World War.

Under the 1902 Act, the Higher Grade Girls' School became the Norwich Municipal Girls' School. The average number of pupils attending it in 1912 was 344. Sisters Ellen and Kathleen Gray from Mornington Road in Norwich were among the girls who had the opportunity to experience a secondary education at this school that they were unlikely to have had if they had been born twenty years earlier. Ellen and Kathleen's father managed a tobacconist's shop and school log books and admission registers show that they both attended Angel Road elementary school before passing the necessary exams. Ellen was a day boarder who joined the school in September 1910. She earned an exemption from paying school fees in 1912 and received a maintenance grant of £5 a year. Kathleen entered the school in 1913, but did not obtain a grant so her parents had to pay. Being able to stay on provided access to wider employment opportunities, with Ellen becoming a clerk in a post office and Kathleen going on to a school of commerce where she would learn typing and shorthand.

Other types of secondary provision began to appear in the late 1800s and early 1900s, especially technical and commercial training. Many were linked to existing technical schools or colleges. Although trade schools were mainly for boys to begin with, some, such as the School of Housecraft for Girls at Norwich Girls' Hospital School, which trained forty girls specifically for domestic service, were obviously aimed at girls. It began its life catering for orphans as part of the Anguish Foundation's residential charity schools, which dated back to the 1600s. The school was relocated to Hospital Lane in Lakenham and became the Girls' School of Housecraft in 1864. For decades after its reincarnation, the school was still referred to as the Hospital School both colloquially and on official documents. Poor girls from across Norwich were sent to board at the School of Housecraft, where they were to be given what was described as a 'plain education', and trained in spinning, knitting and weaving, as well as cutting out, making and mending their own clothes.

Such charities still played a big part in providing education for poor children after the 1870 Education Act. The foundation's funding for the School of Housecraft, for instance, covered most of the costs, but was supplemented by the school board. When the board agreed a grant of £300 a year in June 1879 the chairman argued in favour by pointing out that the school's original endowments had always been intended for the very poorest in the city who could not maintain themselves.

Leah Clara Armes, who later lived at Globe Yard, was one of the girls who benefited, at least for a short while. She joined the school in 1890 aged 10, but the admission registers show that she left two years later 'for home duties'. Leah was typical of the girls who were placed there as they usually joined at between 10 and 12 years of age, although most stayed until they were 15 or 16. Unlike her mother Rebecca, Leah was at least able to stay in school until the age of 12, and she could read and write by the time she left. After the Armes family moved to Globe Yard, Leah's younger siblings, her own children and nieces and nephews all attended Heigham Street Infants School and

gained even more from the extension of the school leaving age and free education.

A number of other organisations also began to appear offering adult education. The Workers' Education Association (WEA) for instance was founded in 1903 to offer social classes and encourage working-class people to take advantage of the growing number of extramural courses offered by universities.

For middle- and upper-class women there were always far more choices, although their education tended to focus more on turning them into good wives, with future employment being the default option for those that did not marry. Among them was Lonsdale School in Norwich, one of the oldest independent schools in England. It was established for middle-class girls in 1823, and moved to Earlham Road in 1895. It was originally a day academy for young ladies, with approximately fifteen students. After the widowed Mrs Harrington bought it in 1864,

Norwich High School for Girls Magazine, Autumn 1915

it was developed into a seminary with specialist teachers of music, English literature and history and domestic economy.

More academic options became available in the latter half of the nineteenth century, despite concerns that persisted well into the twentieth century that women using their brains too much could cause stress, and even affect their fertility. Lonsdale School was among the private schools that responded to demands for wider offerings for women. It started entering students for public examinations in the 1890s with great success and some of its pupils went on to university. By the early 1900s, the school had fifty students and offered music, singing, domestic economy, German, Latin, physical science, mathematics and calisthenics. It remained in existence until the 1980s.

The National Union for the Improvement of the Education of Women of all Classes was founded in 1871 to promote the founding of cheap day schools for girls, and to raise the status of women teachers by giving them a liberal education and good training in the art of teaching. A year later, the union set up the Girls' Public Day School Company to provide first-class academic and moral education for middle-class girls. Norwich High School for Girls was the first school established outside London. It opened in 1875 with sixty-one girls aged 8 upwards, who were to be prepared for life in a similar manner to boys. Although company policy was that there would be no class distinctions, the fee of £16 a year obviously limited the type of students who were likely to attend.

In her history of girls' secondary education in England, Jill Sperandio suggests that the new high school encouraged other private schools in the Norwich area to improve what they offered in order to compete. One pamphlet extolling the virtues of Surrey House School included Ethel Emm's own account of a typical day, which emphasised its pleasant surroundings and high academic standards. The school was progressive, inviting Dr Elizabeth Garrett Anderson, the first female doctor in England, to speak at a prize giving in 1907. In 1908, six members of staff, including the assistant head, took part in the women's suffrage procession. By 1912, it was noted that there were around 1,500 'Old Girls', many of whom had gone

on to become philanthropists, work in medicine, as chemists, teachers, singers, secretaries and research students.

The school's magazine produced by students provides some insights into the opportunities available by 1915 to young women with a reasonable education. Teaching, clerical and secretarial work in banks, at the gas works, finance and family firms were all mentioned. The High School for Girls provided a social life long after they left school should they wish it. Regular old girls' meetings were held, with speakers and entertainments. The autumn 1915 issue, for instance, described the drawing exhibition held in the studio, a musical programme and talk.

Education at a higher level was, however, still out of reach of the majority of women. Although the first female college of higher education opened at Roehampton in 1841, there were still no women at university in 1850. Without a degree it was very difficult for women to enter the professions. Due to the work of the Society for the Employment of Women, and the Englishwomen's Review, the first ninety-one female students

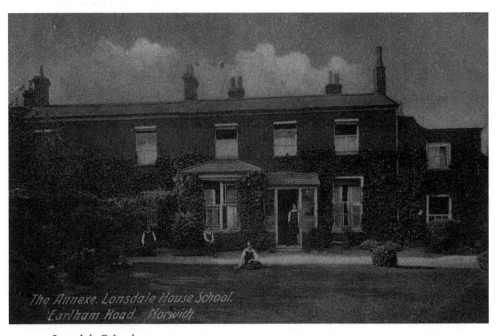

The Annexe Lonsdale House School. Earlham Road. Norwich.

Lonsdale School

entered the Cambridge Local Examination in 1865. However, admission to the examination did not mean women were recognised as university students. Hitchin College for Women (now Girton College) in Cambridge was the first to open in 1870, but was still not recognised by the university authorities. Although others followed, with over 1,000 women students like Margaret Pillow at Oxford and Cambridge by 1910, women had to obtain permission to attend lectures and were still not allowed to take degrees. The University of London was the first to award degrees to women in 1878.

Lucy Bignold was one of the women inspired by the movement to expand access to higher education, and became involved in the University Extension Movement. This began in 1867 as a scheme to promote higher education for women by offering a series of lectures outside the universities. The idea spread across the country, and in Norwich, the first course of lectures was given in 1877. In 1881, a University Extension Committee was formally appointed, with Miss Bignold as treasurer. The Norwich Extension Society was founded in 1897, and Lucy was elected to chair it. She was president of the society from 1921, and remained actively involved in various philanthropic works until her death in 1924, just a few weeks short of her ninetieth birthday.

The first decades of the twentieth century saw increased educational opportunities for everyone. The children with the women of Globe Yard in the photograph taken around 1914 were able to stay on up to 14 years of age from 1918. They could also attend part-time up to the age of 18. At the same time, women's position in society changed enormously. The suffrage movements had secured the vote for some women in 1918, and all women were able to vote on the same terms as men from 1928. By the early 1900s, much had changed for the better in terms of education for women. Very few were totally illiterate, as many of their mothers and grandmothers had been, with the literacy rate for both women and men having reached around 97 per cent by 1900.

During the First World War, all schools across the city played an active part in supporting the war effort, including

the Norwich Municipal Secondary School for Girls (later the Blyth-Jex School). They raised money for relief funds, Belgian refugees, entertainments and Christmas gifts for servicemen and hospital provisions. Putting on concerts and dramatic productions allowed the girls to have fun at the same time; in 1917 alone the school's needlework guild produced 558 garments to go in treasure bags for the Red Cross. The girls' charitable efforts did not end with the war, as the school founded two memorial prizes, one of which paid for a cot in the Jenny Lind Children's Infirmary.

After the war, efforts to improve access to education formed part of projects and legal changes to create a society fit for the survivors and to honour those who had made the ultimate sacrifice. The provision of free secondary education was implemented in 1918, with the school leaving age being gradually raised to 14 by 1921. Nevertheless, on the eve of the Second World War, around 80 per cent of all children still left school at 14, with only an elementary education. The war fuelled the campaign for secondary education for all. Yet the type of education provided for girls in the state sector was still very much focused on what were known as the 'three Rs': reading writing and arithmetic, as well as needlework, cookery, laundry and dairy work. University was still out of reach to all but the most privileged until after the Second World War. Some had opened up to women, but it took until 1920 for Oxford to award women degrees, and it was 1948 before Cambridge did so.

Nevertheless, by 1929, nearly 40 per cent of girls across the country received a full secondary education and gained their Higher School Certificate. In 1935, an official guide to the city's education system described how children were admitted to an infants' school at 4 or 5 years old, where they received formal instruction in reading and numbers through toys, apparatus and picture. At the age of 7 they moved on to a primary school, where the more academic and cultural subjects of history, geography, music, art, handiwork, physical training and hygiene were included. At 11 years old they went on to one of the various types of post primary education.

The educational reforms ushered in under the 1944 Education Act enhanced the lives of Norwich women immeasurably. It aimed to remove inequalities in the system by having three categories of secondary school: grammar, secondary-modern and technical. Where children went would be decided by the results of an examination taken at the age of 11 (the eleven plus). The school leaving age was raised to 15 in 1947. The percentage of free places at grammar schools was increased, and the Act ultimately led to the introduction of comprehensive schools. By 1961, twenty-one new schools had been built in Norwich. But the most important aspect was being able to stay on at secondary school for free.

Although the proposal that the leaving age should be 16 was not implemented until 1972, and equal treatment in education under the law did not occur until the 1975 Sex Discrimination Act was passed, the Act marked a watershed in educational achievement. The pioneering Norwich educationalists such as Mary Colman, Lucy Bignold, Mary Ann Gurney Buxton, Harriet Green and Margaret Pillow, who did so much to shape educational provision for women and girls had all left this earth long before they could witness these latest changes. However, although their focus was very much shaped by the conventions around what was appropriate for females at the time, their dedication and innovations raised the standard of education for women in Norwich immeasurably.

Perhaps the most important aspect for the grandchildren and great-grandchildren of the women of Globe Yard in the photograph, and for others like them across the city, was that by 1950, there was no longer any question that education was equally as important for girls as for boys. Moreover, the increased educational opportunities available to Norwich women meant improved employment prospects and better still, more independence.

Work

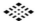

In Norwich between 1850 and 1950, women's work was dominated by textiles, services, clothing, boots and shoes. When the 1851 census was taken, it was still a vibrant city despite a decline in its economic status with the migration of people, skills and jobs towards the industrial centres of the Midlands and north of England. The majority of women and girls listed as working on the census taken that year were charwomen, boot and shoemakers, weavers, shopworkers, domestic servants, nursemaids, factory workers, corset makers and dressmakers.

The women who lived in the twenty-five households at Globe Yard off Heigham Street when the census was taken in 1871 were typical of the types of work Norwich women were employed in. All the married women except three had an occupation, although Ann Havers was described as a 'baker's wife', and Catherine Brown's occupation mirrored her husband's as a 'fish hawker, pensioner', but had been crossed out. The majority of the other married, single and widowed women and girls were laundresses, charwomen, silk winders, fillers, weavers, throwsterers and twisterers in the silk and wool trades, two were machinists, one a brush maker and another a factory hand, while 13-year-old Maria Brown was described as a 'week girl', meaning she was in domestic service.

Much of women's work was invisible, or only partially recorded until relatively recently, even in official records. This was particularly the case for married women. This was in

large part due to the widespread perception of women's role in society as being a wife and mother first and foremost, which in turn contributes to the persistent myth that in the past women nearly always gave up work when they married or had children. The inability to gain a true picture of women's employment is exacerbated by occupational details frequently being omitted from historical records. For instance, a woman's occupation was often not recorded when she married, until well into the twentieth century, even though her husband's job was, while she was often just described as a wife in many documents. Moreover, it was not until 1986 that a mother's occupation was automatically included on the birth certificates of her children.

It is therefore not unusual to come across women such as Sarah Clabburn, who took over her husband's business as a confectioner in the early 1800s, but who was simply recorded on census returns, and even in her own will, as a widow. Few of the women who lived at Globe Yard had their occupations recorded when they married, until the early 1900s, and not always then. Others such as Rebecca Palmer, a dressmaker and the wife of the alehouse-keeper of the Greyhound pub on Greyhound Lane; Maria Wimperis, another dressmaker and married woman of Bullocks Buildings; and Eliza Holman of Duplicate Row, wife of William and a laundress, whose jobs were all recorded on the 1851 census returns, represent the thousands of women whose occupations do not appear on the birth or baptismal records of their children, despite being recorded elsewhere.

The lack of information about women's employment is also due to the nature of the work. From time immemorial women have undertaken seasonal work, night work and working from home. Such work was typically fitted around family commitments, but many women who needed to work still struggled to do so. When the future MP Dorothy Jewson organised a survey into how the poor lived in Norwich in 1912, it was found that in 55 cases out of 306 where there were children in the home, the mothers were working as cleaners and chars, with a large number of their children left alone, or under the

loose supervision of older siblings or neighbours 'keeping an eye out'.

The women who lived at Globe Yard fitted this pattern, with those who had young children overwhelmingly working as laundresses and charwomen, making cardboard boxes and piece-work that could be done at home for the shoe and boot, and silk weaving trades. Despite being a city, agricultural work has always been a major part of Norwich's life even after the Industrial Revolution resulted in the loss of many traditional trades. People living in the city still worked as farmers or agricultural labourers well into the twentieth century, such as Emily Skipper of number 1 Globe Yard, whose husband James was recorded as an agricultural labourer in 1871, while she worked as a charwoman, or her neighbour Elizabeth Riches at number 12 who also worked as a charwoman while her husband was a farmer.

In Norwich, food and drink production (notably beer) tended to be male-dominated occupations, but there were two companies that were large employers of women. The most famous is Colman's Mustard Company which was founded in 1814. After the firm moved to Carrow on the edge of Norwich in the late 1850s it expanded rapidly, eventually ending up as a global enterprise, with a large percentage of its workers being women. From the 1850s onwards, innovative marketing techniques and the opening of railway lines saw the company become a major exporter across the UK and abroad. By the 1870s they were employing 1,500 people, a large percentage of whom were women. By the outbreak of the First World War Colman's was among the 100 largest manufacturing companies in Britain. The company was also noted for its benevolent practices, including providing a welfare worker for female workers, low-cost accommodation and a laundry.

Another food production business with a large female workforce was A.J. Caley, who produced mineral water from 1862. He added drinking chocolate in 1883 and eating chocolate three years later. The company added the making of Christmas crackers in 1898, and had 700 employees by 1904. By the turn of

the century it was producing Swiss style milk chocolate. During the First World War, a new works was built which employed 1,000 people, with the factory supplying 'Marching Chocolate' to troops. By 1935, it had nearly 1,500 employees. The business was sold to Lever Company in 1919. It subsequently became part of Mackintosh company in the 1930s and began producing the famous Rolo sweets, producing up to two tons an hour. It was still a major employer in 1950, although later takeovers and mergers meant the Caley's name disappeared as it first became part of Rowntree Mackintosh and then the Nestlé groups. Although it closed in 1994, thousands of Norwich residents have fond memories of the smell of chocolate wafting out of the factory over towards the market place and beyond.

The decline of the weaving trades had led to widespread unemployment for weavers and spinners in the first few decades of the nineteenth century, but it was still a major sector for female employment in Norwich in 1850. In 1851, 2,878 women were recorded as working in the textile trade in Norwich, forming 19.45 per cent of the female workforce in the city. Nevertheless, that had gone down to 1,122 women fifty years later and just over 6 per cent of the female workforce.

The related clothing trade also employed large numbers of women, mainly working from home or in small workshops as milliners, seamstresses, dressmakers and corset makers. Norwich became synonymous with shawl making in the second-half of the 1800s as pioneered by the firm Clabburn, Sons and Crisp in the 1840s. One of the biggest employers for women in the area around Globe Yard and Heigham Street were the silk and crape manufacturers. Crape had been introduced to the city in 1819, and by 1854 Grout & Company at Lower Westwick Street had around 900 people working there, the majority of whom were women. That same year they were able to report how their silk mills had been in full work all season with their operatives constantly employed in the various processes, either in sorting, stamping, winding, warping or weaving.

Another local factory was the Norwich Crape Company, founded in 1856 and based at Botolph Street by the 1880s.

However, the insecurity of work is evidenced when Grout & Company suddenly announced its closure with a week's notice to workers in 1890. Although several of the Norwich employees were redeployed to their Great Yarmouth factory, it was a major blow to the hundreds of women who worked for them in Norwich. The late nineteenth and early twentieth centuries saw further closures and loss of jobs in textiles and clothing, although some major manufacturers managed to keep going. Rivett and Harmer (later known just as Harmer's) had the largest clothing factory in the city, with its premises on Exchange Street being praised for its light and airy conditions in 1891. Despite the numbers dropping in the twentieth century, there were close to 10,000 people working in Norwich clothing factories in 1950, the majority of whom were women.

The boot and shoe trade had overtaken textile work as the biggest employment area for women in Norwich by the end of the century. Traditionally, much of the trade had been based in the hands of small employers, with piece-work being passed out to people who worked from home. Women closed (stitched) the uppers, which were then passed to the men to be joined (lasted) to the soles, before being passed on to another group of workers to be finished. Whole families were frequently employed in the different stages of creating pairs of boots and shoes.

Women formed 15.44 per cent of the shoemaking workforce in 1851. From the 1850s onwards, improvements in technology and gradual mechanisation meant that much of the work moved into factories. By 1861, the boot and shoe industry was the city's leading employer, specialising in ladies and children's shoes. In 1867 there were twenty-three wholesale manufacturers in the city. By 1900 this had increased to seventy-seven, and Norwich became the home of international companies such Clarks and Start-rite.

Although there were some fluctuations, both up and down, there were 2,902 women shoemakers in Norwich in 1911, forming 14.54 per cent of the female workforce. Ten years later this had dropped slightly to 2,853 women, but had risen to 4,655 women in 1931, forming 22.62 per cent of the female workforce,

with the total number of shoemakers being 10,800. Although there was a major decline after the Second World War due to overseas competition, the shoe trade was still a major employer of women in 1950.

Domestic service was still the largest employment sector for women throughout the nineteenth century, particularly of the young and single. Jobs classified as female domestic service included housekeepers, cooks, kitchen and scullery maids, housemaids, chambermaids and nurses. Across England and Wales there were 1,494,411 domestic servants recorded when the 1871 census was taken, the majority of whom were female. Breaking it down further, there were 140,836 housekeepers, with an average age of 45. Female cooks numbered 93,067 (average age 30). There were just over 100,000 housemaids, most of whom were aged between 15 and 25, as well as over 75,000 nurses and 20,000 female hotel servants.

In Norwich, nearly 4,000 females were recorded in domestic service in 1851. This had risen to 5,458 in 1861; almost a third of the female workforce. Twenty years later there were 5,773, and by 1901 5,456.

Sarah Seaman was perhaps typical of many women who never married and whose options were even more limited due to their social class, meaning certain jobs such as factory work were considered unsuitable. She was born in Norfolk to comfortably off farmers in 1810, and one of her brothers became a wine merchant and sheriff of Norwich. After her parents' deaths she moved into Norwich, where she became housekeeper to her widowed brother Robert. When he remarried, she was in her fifties and redundant, but became a live-in housekeeper to family friends. It was a precarious existence for many single women in similar situations, particularly once they became too old to work. Fortunately for Sarah, her brother Robert and other relatives ensured she had a home and income. Nevertheless, neither the death notices posted after she died in 1904, nor her own will, or those of relatives that predeceased her, give any indication that she ever had any kind of employment as she was simply referred to as a spinster.

The numbers of servants began to decline in the early twentieth century for a variety of reasons. In particular because industrialisation and other social changes made other jobs more widely available to women. Nevertheless, there was still a significant percentage of people, mainly from the lower classes, working in other peoples' households as servants in the first-half of the century.

For many women, their work was actively assisting with a family trade or business, although the full extent of their involvement can never be truly known as so many were simply recorded as the wives of butchers, bakers and shopkeepers and so on. However, some come out of the shadows when they carried on a family enterprise after the death of a father or husband, while large numbers of women also set up small enterprises of their own, most notably in service industries and traditional female spheres.

Mrs Susanna Harper, beerhouse keeper and grocer at Globe Street in 1883, was just one of the huge number of women who increasingly began to appear in Norwich trade directories in this hundred-year period, running shops, inns and boarding houses. Another was the Santa Lucia Hotel on Yarmouth Road, set up by Mrs Duncan in the 1930s. The numbers of women running small businesses and in trade increased massively by the early 1900s due to greater opportunities, legal changes and expansion of education.

Some enterprising women, such as sisters Rachel and Mary Ann Baldwin, put their 'female' skills to good use. They co-ran the Model Laundry at number 18 Philadelphia Lane, which their mother Rachel had begun in around 1869, when she began advertising to take on two or three families' washing. The two sisters started by working with her then continued after her death. By the 1880s they were promising an excellent drying ground and rooms, and could supply good references. Mary Ann died in 1896, and Rachel continued with the laundry on her own. By the turn of the century she was advertising for ironers and offering services to hotels and schools, including 'polish shirts and collars'. By 1907, the business comprised a

washing room and drying room fitted with coppers, company's water and a patent dryer.

One of the largest laundries in the city was the steam powered Swan's Laundry on Waterworks Road. In 1883, its manageress was a Miss Elizabeth Jane Penfold. All of its workers were women, and as it was only a five to ten minute walk away, it undoubtedly employed some of the women who lived at Globe Yard and other streets nearby.

Elizabeth Eastoe Sabberton (née West) was another woman who continued running her husband's business, on Thorpe Road, after his death in 1879. What was more unusual is that she did not just employ a man to run it on her behalf, but did so herself, giving her occupation on census returns, in trade

Riches Richard William, builder; & at Postwick
Sabberton Elizabeth Eastore (Mrs.), blacksmith, The Foundry
Spooner John, boot & shoe maker
Steward William, farm bailiff to J. W. Reynolds esq. The Farm
Tassell Frederick Samuel, beer retlr. & convenient stabling provided
Thorpe & District Athletic Club (Frederick Garton, sec)
Thorpe & District Miniature Rifle Club (Louis W. Clabburn, hon.sec)
Thurston Wm. painter & decorator
Todd David, cab owner
Waters John, pork butcher
Withers Robert, insurance agent
Woodcock Jsph. tailor & upholsterer

Elizabeth Sabberton listed in Kelly's Norfolk Directory, 1908

directories, advertisements and in her own will, variously as a blacksmith, engineer and iron founder. As Elizabeth Sabberton was a widow and ratepayer she could vote in local council elections, although she could not do so in parliamentary elections. She also took on and trained a female relative called Edith Elizabeth Moughton as a blacksmith and shoeing smith. When Elizabeth died in 1909, aged 87, she left Edith the business premises in her will.

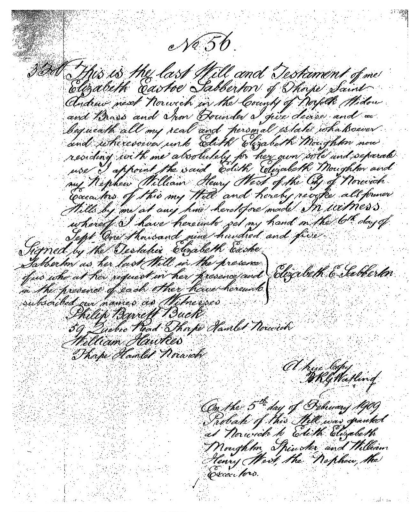

Will of Elizabeth Sabberton, 1909

By the early 1900s, Norwich had a higher than average percentage of female workers in factories. This was largely due to the type of work available, such as packing chocolate, which was considered well suited to women. All factory jobs paid lower wages to women. In 1906, the average wage for a male shoemaker in Norwich was 28*s* 8*d* per week for a fifty-four hour week, while women earned 13*s* 1*d*. In the clothing factories in the same year, women earned an average of 10*s* 9*d* as opposed to the 28*s* 4*d* a week that men received. City wages were also much lower than the national average. Again, this was in part due to the number of women employed, but also due to the prevalence of piece-work. Trade unions had little success in improving rates of pay, with many firms such as Harmer's and Caley's adopting strict anti-union policies well into the twentieth century.

The occupations of the women living at Globe Yard off Heigham Street, and other streets nearby such as Dereham Road, Orchard Street and Tinklers Lane, as recorded on census returns give a partial glimpse into the world of women's work in Norwich in the early years of the twentieth century. When the 1911 census was taken, there were nineteen households at Globe Yard, plus one empty property. None of the wives were recorded as being in work, although other sources such as newspaper reports indicate that some of them did have jobs as laundry women, market stall holders, seamstresses and cleaners.

Out of the single women and widows, 53-year-old Emma Burrell was a sewing machinist. Her neighbour, 20-year-old Alice Betts was a bookbinder, while her 15-year-old sister Emma was a general domestic servant. Matilda and Violet Armes, aged 22 and 15 respectively, were both silk weavers. Beatrice Smith at number 8 worked as a charwoman, despite having a very young child to care for. The rest of the women and girls living at Globe Yard in that year worked in the boot and shoe trade, apart from one who had a job in a sweet factory. There was a similar pattern with other women living nearby, although the type of factory work sometimes varied. Among them was the widowed Rose Harper of Globe Street, who worked as a wood

machinist while her eldest children, including her daughter Mabel, worked as cardboard-box makers.

While women were excluded from many existing professions and jobs such as doctors and lawyers for much of the nineteenth and early twentieth centuries, they did begin to make inroads. They also began to enter into new and expanding areas of employment in the late 1800s and early 1900s such as typists, post office workers, clerks, telephonists, waitressing and shopwork. Norwich's first female doctor was Ethel Louie Starmer. Her family had moved to Norwich where she lived at Cedar Road and worked as a schoolteacher of English and drawing before attending Edinburgh School of Medicine for Women. She qualified as a doctor in 1897 and returned to Norwich to work. Ethel soon went on to work as a medical missionary in China, fleeing twice during the Russo-Japanese war and then the Boxer Rebellion. After the First World War she set up practice in Belfast, where she was still working in the 1940s under her maiden name, although she had married in Shanghai in 1922. Ethel later returned to Norwich, where she died in 1965.

Nevertheless, despite such progress by some women, a report by the Ministry of Reconstruction in 1919 showed that the vast proportion of female employment was still in casual work, and that they formed a large proportion of homeworkers.

Teaching and nursing were the other growth areas for female employment throughout the nineteenth and twentieth centuries. The number of women becoming teachers grew enormously between 1850 and 1950. It was one of the few areas seen as respectable for middle- and upper-class women who needed, or wanted, to earn a living. Many set up their own schools or went to work for others such as boarding school owner and teacher Lucy Brewer. She was born in 1822 into a comfortable middle-class home. As an adult, she first lived with her married sister Rachel Stocks, and worked as a schoolmistress. Having set up her own small boarding school for boys from 6 years old at her home in Town Close in Norwich, her sister went to live and work with her after being widowed. A glimpse of the clientele they were aiming at can be seen in advertisements such

as the one in the *Norfolk Chronicle* on 10 August 1878, which stated that the school was highly recommended by Clare Sewell Read, MP.

For schoolteachers, the government pupil-teacher system introduced in 1846 enabled working-class girls to train while being employed. This involved a five-year apprenticeship, after which they could sit a scholarship exam for a place in a college. Those who did not take the exam could still teach as uncertificated (assistant) teachers. One contributor to 'Within Living Memory' recalled the stories passed on by her mother who became a pupil teacher at Carrow School in 1887. This was the school built for the children of employees by Jeremiah Colman. Her training consisted of teaching elementary subjects during the daytime, and preparing lessons and studying for her teaching certificate in the evening.

The 1870 Education Act had standardised training in the National and British Schools, which became the foundation of the state system. Women had two routes into teaching: one as pupil teachers, and the other via the growing number of teacher training colleges. Serving teachers could become certificated without examination at the discretion of the inspectors, but new teachers had to undertake the five-year apprenticeship. Many Norwich women such as Miriam Pratt took this route. The log books for Carrow Girls' School in Norwich record her receiving a scholarship to the Higher Grade School in August 1902. Later records for Thorpe Hamlet school note her commencing duties as a certificated assistant.

The Norwich Training College began as the Diocesan Training Institution for training teachers within Church of England Schools. When it opened it had a superintendent, with six female and four male students. After it moved to St George's Plain it focused on training female teachers, and remained so until the 1960s. The training college relocated to College Road in 1892, at which time it became the Norwich and Ely Training College. It finally moved to Keswick Hall in 1948, and subsequently became part of the University of East Anglia campus when that opened in the 1960s. A letter in 1896

describes how regimented the lives of the trainee teachers were. Every day, breakfast was followed by a church service, before a day filled with lectures, including drill (PE) and needlework, and interspersed with short breaks until 7.40 pm, when they had to attend another service. Contact with others apart from teaching practice was limited and they were rarely allowed to leave the grounds, and only if accompanied by another student.

Female teachers became much more in demand during the First World War, and the Norwich Training College added advanced botany and gardening to its curriculum. Rhoda Cook recalled her time at the training college between 1926 and 1928 for a college history. The daily routine was lectures in the morning with a break for a drink and bread and dripping.

NORWICH TRAINING COLLEGE

THEORY OF EDUCATION.

Saturday, November 16th, 1912.

Three Questions only are to be attempted.

1. Describe and illustrate the main principles of geographical teaching.

2. Give, with your reasons, some account of the method or methods that you would use for the teaching of history

 (a) in the preparatory stage.

 (b) in the last stage of school life.

3. What do you consider to be the function of music teaching in school? Show how you would endeavour to make your work illustrate this.

4. Describe carefully how you would conduct a school journey. Discuss fully the importance of this.

THE COLLEGE, NORWICH.

Saturday, 23rd November, 1912.

(Answer THREE Questions, choosing only One from a section, except IV.)

I.—(a) What do we know of St. Luke from the New Testament? What bearing has it upon his qualifications as an Evangelist, or upon anything in his Gospel?

(b) St. Luke's has been called "The Universal Gospel." Explain such a title; and illustrate it by mentioning features, incidents, or parables distinctive of this Gospel.

II.—(a) In what way did our Lord's teaching differ from that of the Rabbis? Show how He drew lessons from ordinary life and from nature.

(b) Indicate briefly and clearly what explanations and teaching you would chiefly work out in a lesson on the Transfiguration.

III.—(a) What various lessons about Prayer may we learn from this Gospel?

(b) Explain carefully what principles our Lord taught about observance of the Sabbath.

IV.—Explain TWO of the passages :—

(a) "A sword shall pierce through thy own soul also."

(b) "From him that hath not, even that he hath shall be taken away from him."

(c) "Strive to enter in at the strait gate."

(d) "Ought not Christ to have suffered these things?"

V.—(a) Point out and explain references to different parts of the Temple.

(b) Quote or refer to, and state clearly, different uses of the expression "the Kingdom of God."

(c) Enumerate the phases of our Lord's trial: Quote the Words from the Cross: State the chief appearances recorded of the Risen Christ. (In each case give either all, or else those in St. Luke only.)

A page from the Norwich Training College Exam paper on 'Theory of Education', 1912

Norwich Training College, 1913

Afternoons were spent on hockey, netball, and tennis in the summer. They were trained to teach children simple exercise and dances. If the afternoon was free they could walk into Norwich for tea, then lectures resumed again until suppertime. When Marguerite Watts attended between 1942 and 1944 the college and teachers were in temporary accommodation because the college building had been destroyed by bombing. While it was not quite as restrictive as when Rhoda attended, there was still a nightly curfew and no male visitors allowed on the premises after 9 pm.

The numbers of women in nursing and midwifery also increased, and they became more professionalised as training schemes were expanded and more regulation was introduced. The rise in status of nursing in the latter-half of the nineteenth century, as well as more work opportunities in hospitals, workhouses and other institutions, undoubtedly made it more attractive and accessible to women to work in.

In Norwich, Colman's Mustard employed Philippa Flowerday as the first industrial nurse in England. Philippa was

born in North Walsham in 1846. When the 1881 census was taken she was 33 years old and recorded as a 'sick nurse' living at home in Lakenham. When the new hospital was built, and the site of the old Norfolk and Norwich Hospital was developed some years ago, a road was named after Philippa on the section where the maternity block once stood.

Another famous nurse with Norwich connections was Edith Cavell. She was born in Swardeston, and went to school in Norwich, where her mother later lived. Edith came to international attention for her heroism during the First World War, when she was executed by the Germans in 1915 for helping British servicemen escape from Brussels. However, she had already built a career working as a governess first, then a nurse. She became an assistant matron before moving to Brussels to train nurses and where she helped revolutionise and improve the country's medical system.

Much changed for women's employment during and after the First World War. At first, the war had a detrimental effect on women in the city. This was due to the sharp rise in unemployment in Norwich in industries such as clothing, shoemaking and food processing, as these were especially badly affected by the loss of export markets and problems in obtaining supplies. In silk weaving alone, 200 women were immediately suspended from work when war was declared. In October 1914, the Distress Committee reported 523 female applicants for relief. By March the following year this had risen to 744.

One attempt to alleviate the problem was a toy workshop which Dorothy Jewson helped to set up in 1914 for retraining unemployed women. This was jointly funded by the Local Government Board and local charities and the toys were sold locally. It was maintained by voluntary subscriptions and had thirty-seven girls aged between 15 and 18 working there when it began. Most were former silk weavers, or brush and sweet factory workers. However, as women began to move into war work, fewer young women joined the toymaking workshop. When it closed in 1917, the Norwich High School for Girls magazine (*Parvum in Multo*) noted that former pupil Annie

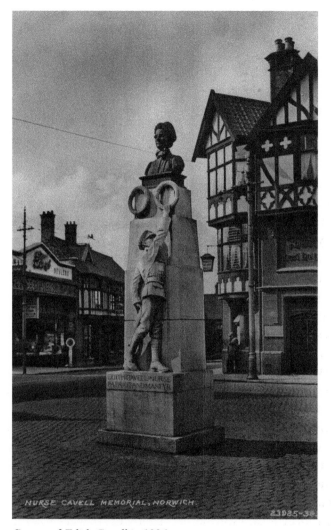

Statue of Edith Cavell in 1936

Howlett was left in charge of the stock of toys at the factory in St Margaret's that had been set up by some of the Old Girls, and wrote:

> We share her and her former colleagues their great disappointment that a venture which, at the cost of much thought and labour, had been worked up to a position of

great promises and should have proved helpful towards the solution of after-war problems, has, owing to the indirect consequences of the discouragement of luxuries, been suddenly closed.

Nevertheless, Dorothy Jewson put her experience to good use by helping to organise the National Federation of Women Workers. This had been founded in 1906 to encourage women to join trade unions, and was an offshoot of the Women's Trade Union League. Despite obstacles, the Federation had grown to 20,000 in 1914.

As the war progressed women in Norwich, as elsewhere across the country, were recruited to replace men. On 17 March 1915, the Board of Trade appealed for women to work in any kind of paid employment. Within a week 20,000 women had signed up. The Ministry of Munitions was created in 1915 and the effort to increase the supply of items needed for the war was encouraged by the Women's Right to Serve march in July that year, which saw 30,000 women march through London. Thousands of women began to enter the workforce who had not done so before, as well as take on traditional male work. In Norwich, more women were employed by Colman's Mustard than ever before, as was the case in the shoe factories.

The National Union of Boot and Shoe Operatives initially opposed female workers taking male jobs but, following the Treasury Agreement of 1915, it was agreed that women could be employed if no male labour was available.

Many local companies turned to war work. Harmer's was already producing military uniforms, so was able to increase production very easily. They added knitting machines and produced a mile of knitted fabric a day during the war. By the end of 1914, 200 women were making uniforms for a local regiment at Chamberlin's textile factory. Such was the demand for waterproof clothing and oilskins that Chamberlin's had to build a new factory to cope and were employing around 800 women by the end of the war.

At the same time some Norwich shoemakers survived by adapting to produce footwear for the armed services. Howlett

and White Limited, for instance, lost 90 per cent of its workforce to the services; they were replaced by women in order to cope. Throughout the war, the female dominated workforce at their factory produced 474,000 boots and shoes for the British armed forces, and 32,000 pairs for the Allies, as well as hospital slippers for wounded servicemen and shoes for the Women's Army Auxiliary Corps.

When the war began, Norwich already had a strong engineering base. As a result, Boulton & Paul, Lawrence Scott, Mann Egerton and Howes & Sons and other local firms were awarded numerous military contracts, including building aircraft and shell production. Although there was initial opposition to employing women, they had little option, and a training school was set up at Boulton & Paul to provide the women with engineering training. This was so successful that it attracted representatives from firms across the country who wanted to emulate their methods and success. The women based at the Riverside factory worked on every aspect of producing aeroplanes and flying-boat hulls, from welding, carpentry, fitting, varnishing and applying weatherproof coating to the aeroplanes' fabric.

Around 1,800 munitionettes were also recruited by Boulton & Paul to manufacture fuses for shells, working non-stop in three eight-hour shifts to produce over 2 million fuses by the end of the war. The women were nicknamed 'canaries' because they worked with chemicals that turned their skin yellow; many were killed or injured in explosions. The women earned less than half that of men for the same job and hours, although it was far greater than many had earned previously, and they could buy subsidised meals from the women's mess room. The National Federation of Women Workers, which included Norwich-born Dorothy Jewson as a leading organiser, played a vital role in securing better pay and conditions for the workers.

Some women were promoted and Miss Lewis, who was the forewoman of the women's fitting shop, was recruited by the Ministry of Munitions to help organise its national employment of women. The company also provided a range

of welfare services, with female superintendents employed to organise and oversee their facilities. There were also a great number of leisure activities ranging from weekly dances to stage entertainments which raised funds for the war effort and boosted the morale of wounded service men being treated in local hospitals.

Although munitions work was primarily the preserve of working-class girls, many of whom already had experience of working in factories, it did draw in girls from other social classes. The Norwich High School for Girls' magazine, which was written by pupils, noted the kinds of war work many of its former pupils were engaged in. In the autumn edition of 1915, there were several pages of listings of former pupils engaged in war work. Dairy and agricultural work featured strongly. Among them was Audrey Day, who was being trained at the Corporation Farm at Whitlingham, while working at Illington near Thetford. There was also a mention of three former students who were in 'motor garage work'. Some women had gone into munitions work, with Margaret Burton being described as making munitions on Sundays, and working at an office during the week. It was also noted that Marjorie Beattie and Noel Wright had been placed in aeronautical draughting at Boulton and Paul, with Marjorie's job being a tracer.

There were also some masseuses, Red Cross workers and nurses, with several of the latter being placed at the General Hospital in Alexandria and as part of the ambulance train in France, as well as in other military and Red Cross hospitals at home and abroad. Among those who had gone into nursing was C.K. Lock at Bracondale Hospital, while Alice Pearson was working for a doctor in London after acting in the same capacity in Harleston. Marjorie Boswell was based at Netley Naval Hospital, while Millicent Howard (née Stacy) had begun nursing at the Norwich Workhouse Infirmary after a year in munitions work. Quite a number of former High School pupils had also gone to work in offices, and at the autumn meeting of former pupils, Miss Wise drew attention in a talk on war work to the training classes for clerks now being held in Norwich.

Apart from the war work, the list of occupations published in the Norwich High School for Girls' magazines in this period give some insights into the opportunities available to young women with a reasonable education. Dorothy Everetta, for instance, had become a lecturer in English at Holloway College after taking a post graduate course at Harvard in America. Dorothy Jewson also had a special mention as the Organiser for the National Union of Women Workers in Newcastle. Clerical and secretarial work in banks, at the gas works, finance and family firms were all mentioned, and teaching was still popular. The war also exposed many of the girls to types of work they might never have experienced otherwise. One of the articles included in the autumn 1915 magazine described one of the old girl's roles as an enumerator for the National Registration Committee (appointed July 1915). 'Here I learned many things new to me – what a book skiver is, that chocolate wrapping is a trade, while chocolate packing is unskilled labour, and looked down on by those who wrap'.

Norwich women were also among those who signed up to serve on the home front and abroad. The Navy was the first of the armed forces to recruit women, beginning in 1916 as part of the auxiliary patrol. The following year the Women's Royal Naval Service in 1918 (WRNS) was formed, as was the Women's Army Auxiliary Corps (WAAC) and Women's Land Army. The WRNS became known as the Wrens and by 1919 over 7,000 women were working in a range of roles from domestic to intelligence. The Royal Naval Service (RNAS) had formed in 1914 and many women worked on naval air stations, where their work related to aeroplanes. The majority transferred to the Women's Royal Air Force when it formed.

The WAAC women were allocated to either the cookery section as cooks and waitresses; the mechanical section as driver mechanics; the clerical section as clerks, typists, telephonists and messengers, or miscellaneous. Ironically, many of the WAAC women were not discharged until after the majority of servicemen as they were kept on until the end of 1919.

In April 1918, the separate sections of the Army and Navy were amalgamated to form the Royal Air Force, and the

Women's Royal Air Force (WRAF) was formed at the same time. WRAF women were also allocated to work as clerks, typists and telephonists, cooks and waitresses, as well as undertaking technical work and general work such as being riggers, packing parachutes and as drivers. Many worked at one of the local airfields and landing strips in Norfolk. Those with an exemplary record could volunteer to work in France and Germany. The WRAF was disbanded in 1920. The Women's Land Army was set up in 1917 to train and provide a civilian labour force of full-time workers for farm work. They were essential in keeping food production going during the war as there were simply not enough men left behind to do so.

One of the less well known traditional male roles that women took on during the war was as firefighters. They were employed in private brigades to fight fires and carry out rescues. Chamberlin's department store on Guildhall Hill was one of those that appointed its own brigade of women to protect the store and neighbourhood around it by attending air raids, putting out fires and rescuing people. While most of these troops were disbanded after the war, there were still some female firefighting teams in parts of the UK in the 1920s and 1930s. Women began to play an even more significant role in the fire service during the Second World War, although it was not until 1976 that the first woman firefighter was recruited.

The end of the First World War caused significant changes in women's employment as well as the economy generally. Within days, a large section of Harmer's clothing factory came to a standstill. Elsewhere women left their jobs to make way for returning servicemen. The interwar years were a time of significant change. The women who worked in 'men's work' had to give up their jobs to returning servicemen. Although some women wanted to give up work, and others were encouraged or even forced back into the domestic sphere, the world had changed. There were efforts to find employment for single women and widows as domestic servants, but large numbers of women were unwilling to return to lower wages and a life of servitude.

There were a small number of women like Margaret Pillow, who had careers both before and after marriage and children. Teaching was one of the few areas in which this was possible. As already seen, Margaret had taught at all levels in schools before her marriage, ending up as a headmistress as well as being a renowned author of books and articles on domestic science and domestic science teaching. In 1890 she passed the examination of the Sanitary Institute in sanitary science and law, becoming the first female sanitary inspector in the UK. The following year she was selected by the Council of State Hygiene to prepare and read a paper on Woman's Work in Promoting the Cause of Hygiene at the International Congress of State Hygiene and Demography. Her work included training women lecturers and teachers on health and kindred subjects to prepare them for sanitary work among the poor. Her lectures on behalf of the National Health Society to the trainees included pointing out the various appliances connected with drainage, water-supply, ventilation, disinfection and so on, as well as explaining the principles of their construction and their practical work in application.

Margaret's political interests obviously extended beyond education, as when she married it was noted that the reception was held at the residence of Mr and Mrs Pankhurst. She devoted much of her time to improving girls' education, while continuing to work as a schools' inspector.

Margaret was also a working mother. She set up her own cafés when her children were quite young, firstly in partnership with another woman, then as sole proprietess. She continued working after she was widowed and was still running Prince's Tea and Luncheon Rooms on Castle Street until very shortly before she died in 1929. The 'commodious, bright, airy and attractive' premises specialised in wedding, birthday and christening cakes, and boasted of its noted invalid jellies and home-made cakes. Unusually, when her husband died his obituary mentioned her career as well as his, although when Margaret died she was simply referred to as the wife of Edward, followed by what he did for a living.

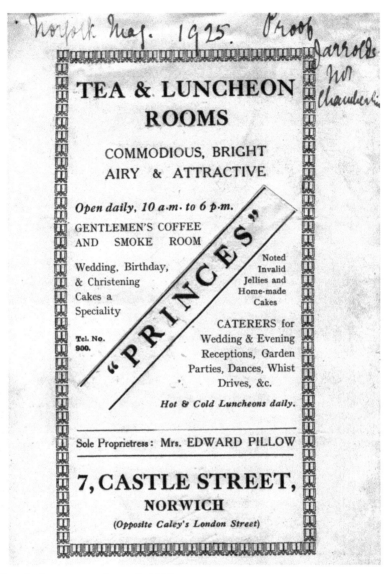

Proof advertisement for café, 1925

Although the economy in Norwich recovered to a great degree immediately after the war, it did not last long and unemployment rose in the 1920s. The largest employer was still the shoe industry. By 1931 it employed 17 per cent of the workforce. Its female workers comprised 22.6 per cent of all

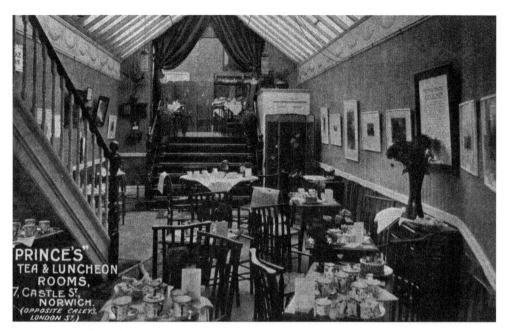

Prince's Café

women in work. However, economic pressures meant that over 50 per cent of the shoe industry were on short time at the end of 1930, with many small firms going bankrupt or closing down. There were success stories such as Sextons who developed branded high quality lines, while other companies joined forces and amalgamated. The move towards more machine-sewn shoes increased the use of unskilled female labour in the city, so women's employment in the shoe and boot trade increased as work for men decreased.

Employment for women in the textile trade dropped from 703 workers to 456 between 1911 and 1931, while the clothing industry plummeted from 3,614 in 1911 to 1,364 twenty years later. Some local department stores such as Jarrolds continue to thrive, while Chamberlin's department store continued to trade until it was sold in the 1950s. There was still a substantial amount of work available in food and drink production, but the number of women workers had dropped from 1,907 to 697 over the same period. Like the shoe trade, long established

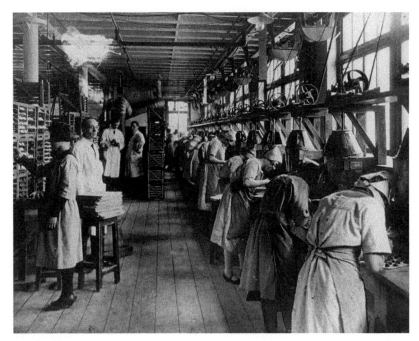

Caley's factory workers handmaking chocolate in the 1920s

companies such as Colman's and Caley's began merging with others.

The number of women working as teachers and nurses continued to increase in the twentieth century, but one of the largest growth areas for female employment in the city was in white collar work. The numbers classified as in commerce rose from 439 to 2,203 between 1911 and 1931. In 1911, there were no female clerks or typists recorded on the census returns for Norwich, but there were 2,095 twenty years later. The burgeoning insurance industry no doubt played its part. In the 1800s women were only employed by Norwich Union as domestic workers to begin with; it was 1895 before women were first employed as insurance clerks. The number of female clerks and typists increased rapidly during the First World War. Although many were dismissed at the end of the war, a significant number were retained. A Norwich Union magazine in 1921 suggested this was due to office life being more attractive financially and

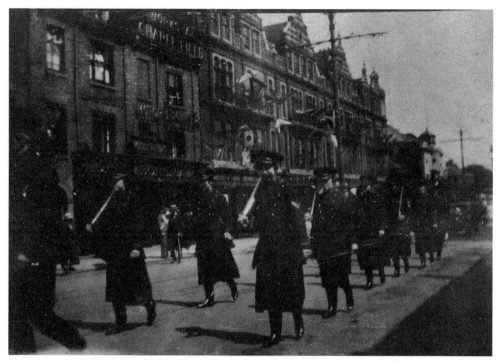

Chamberlin's Ladies Fire Brigade parading in the city First World War

socially than working in a shop. It also noted there were fewer opportunities for marriage due to the number of men killed during the war.

One of the women who made their mark in the company was Miss Lilian Dell. She was appointed the first lady superintendent of the head office of the Norwich Union Fire Society in 1915, and became the first 'chairman' (*sic*) of the women's section of the Norwich Insurance Institute in 1929, and advised the company's Life Society in 1937 when they finally decided to employ women in their head office.

There was, however, no attempt to treat the women working for Norwich Union equally. A salary guide from 1946 reveals that there was no allowance made for women's salaries to increase after the age of 29, although their male counterparts did. There was also no pension fund set up for female workers until 1940, and as late as 1963 women were expected to give

up work when they married, although they could apply to join the temporary staff. Nevertheless, for many decades Norwich Union was able to promise it had a job available for every school leaver in the city.

The number of women in the professions in Norwich had, however, decreased from 1,336 by 91 between 1911 and 1931; domestic service was also in decline. Norwich was no different from other cities and large towns in suffering the effects of the depression in the 1930s, with massive unemployment and low wages. The disparity between men and women's wages carried over to unemployment benefit. Dorothy Jewson was one of those who, in 1936, condemned the practice of granting women two shillings less than men a week, and female young persons one shilling less than their male counterparts, simply on the basis of gender.

Although the shoe and clothing industries continued to be major employers between the wars, unemployment rates were high and wages low. Women filled the place of men once more during the Second World War, but again at lower wages. By the end of the Second World War it was evident to councillors that significant expansion was needed in the local economy. The 1945 City of Norwich Plan, which aimed to help rebuild the city after the war, meant there was a large investment in infrastructure. There were still twenty-five shoe companies employing nearly 10,000 people in 1949, but despite the efforts made to support local manufacturing businesses, a large number closed or merged over the next thirty years.

At the end of the war women had to step aside for men once more. However, the growth of clerical and insurance work, the raising of the school age and expansion of educational opportunities meant that there were far more employment opportunities for women than ever before. While married women were still expected to give up work, and equal pay and maternity rights were some way in the future, there had been much progress since the beginning of the century, and the world in 1950 was full of unimaginable opportunities compared to 1850.

Marriage and Relationships

In 1850, the place of women in Norwich and elsewhere was still under the thumb of men. Legally, women were under their father's control until they married, when they were given to their new husbands and then became his property. While a single woman or widow could own property and keep her own earnings, a married woman could not. What was hers became his in name and in law.

Women from middle- and upper-class backgrounds were often given some legal protection via marriage contracts. Women such as Emily Gray Ward had such prenuptial arrangements put in place in order to give them rights over their property and to leave a will. When she married the second time in Norwich in 1841 after being widowed, she arranged her own contract, whereas her father had been the main party to the first. As a widow she was independent, but by marrying again she would forfeit the pubs and houses she had inherited from her father and first husband if no such contract was drawn up. Emily died within a year of her wedding to Robert Seaman, and when Robert remarried another marriage contract was drawn up between him and his second wife's father and brother. By the time he died such an agreement was no longer necessary, but the marriage contract provisions were still referred to in his will.

With or without a marriage contract, the careful wording of bequests in wills could ensure women did not lose out. This was by leaving property and money for their sole use, as happened

with Catherine Clabburn, of Thorpe in 1849, when her husband left her his whole estate. Although they may have had a marriage contract there was no mention of it. Having sole use meant that Catherine could write her own will and dispose of her estate as she wished without restrictions, as occurred when her will was proved in 1857. She also took great care to specify that the bequests given to all the females named in it were for their sole use and benefit only, without any interference from any present or future husband.

Nevertheless, Catherine was only able to write a will without permission from a man as she was a widow. If she had remarried, then she would have lost that right and everything she had would have become his, unless a contract was drawn up to say otherwise. When another relative, Thomas Clabburn, died in 1858, he too gave his wife sole use of his house and money, but only during her lifetime. If she married again then she forfeited everything except the portion agreed in their marriage contract.

Until legal reforms in the late nineteenth and early twentieth centuries, women had the same legal status as lunatics. A man could beat his wife with a stick as long as it was no thicker than his thumb, which is the origin of the phrase 'a rule of thumb'. Women first petitioned parliament to remove married women's dependence on men in 1858, with many nineteenth-century observers comparing marriage to slavery for women. Yet, it was another twelve years before the first very limited property act gave married women some rights.

Even after legal reforms and the introduction of divorce in 1858, a married woman's property automatically became her husband's. The first Act of Parliament to grant women some rights was in 1870, when it was ruled that a husband could no longer take his wife's earnings. Another in 1874 granted women some limited rights of ownership over property, but it was not until 1882 that women were fully entitled to retain ownership of property, or to be able to make a will without their husband's consent. Women continued to be discriminated against when seeking a divorce by having to show more cause than a man until 1923.

The one advantage for a woman was that it meant her husband was responsible for any debts she might incur. Therefore, if a couple separated, or a woman left her husband it was common to see him take out advertisements to say he was not responsible for any debts she incurred. For example, on 30 March 1864 the *Norwich Mercury* carried two identical adverts from William Henry Bingham of Sussex Street regarding his wife Lucilla, and John Lyall Wortley of Prince of Wales Terrace relating to his wife Elizabeth. Even after the Married Women's Property Acts, it was still common to see advertisements such as the one taken out by William Edward Beckham of Dial Square in the *Norwich Mercury* on 3 September 1887, in which he stated: 'I hereby give notice that I will not be answerable for any debts contracted by my wife, Jane Beckham, after this date.'

What little we know of the internal workings of women's relationships between 1850 and 1950 either comes from a few upper- and middle-class women via letters, diaries and memoirs, or through newspaper reports, court records and other secondary sources. Even less can be discovered about women who were lesbian or bisexual. Societal pressures, expectations and attitudes towards women's sexuality mean we can never know how many of the women who lived together as companions were more than friends. The invisibility of such relationships is exacerbated by friendship often being overlooked in historical accounts as a type of relationship. For instance, Dorothy Jewson was far from the only woman to have lived with a female companion for many years, or the only one who shared a home with a friend before marriage or after widowhood.

Glimpses of courtship practices, wedding arrangements, married life and relationships are therefore only partial. For instance, an account of the wedding arrangements of Jeremiah James Colman, founder of Colman's Mustard, and Mary Burlingham, and their honeymoon journey visiting mustard fields and stopping at King's Lynn, Cromer and other places, was recounted in a history of the family published privately in 1905 by Helen Caroline Colman.

When Thomas Clabburn and Blanche Gould married in December 1851, local newspapers reported the details of the substantial celebratory dinner his father arranged for the workers at his shawl making business in Norwich. Neither is it unusual to find such detailed descriptions as the report of the wedding of Louisa Mary Harbord of Town Close House, Ipswich Road to Philip Edward Ripley in 1887. Louisa's family were well known locally, and several column inches in local newspapers were devoted to the scene inside the church with its tasteful floral arrangements and her procession down the aisle in a white striped silk dress with a matching train. The well-wishers then saw them off to their honeymoon on the Isle of Wight.

When Mrs Gifford of Globe Yard off Heigham Street died in 1888, aged only 37, her husband was so bereft he took out several death notices in different newspapers lamenting his loss. Such happy and successful relationships tend not to make it into the public consciousness in the same manner as dramatic and tragic tales. The personal lives of the vast majority of women were never recorded unless they were newsworthy in some way.

Moreover, romantic visions of a couple embarking on a life of wedded bliss is in stark contrast to the reality for huge numbers. In May 1903, the personal life of Emma Cushion of number 9 Globe Yard made the newspapers when her estranged husband, Anthony, was attacked by the man she was living with. They had lived apart for seven months when Anthony made a visit and she was with William Charles Short. The result was Emma's lover being jailed for six months with hard labour. Whether this influenced her decision to return to her husband is not recorded, but the tragic death of her daughter in a fire the following year reveals that Emma and Anthony were reconciled. In 1911, Anthony was living with their son in Norwich, but Emma's whereabouts are unknown.

On Tuesday, 22 April 1851, Jane Field ran for her life along Pump Street near King Street at one o'clock in the morning. Witnesses described how James Flood ran after her, knocked her down and beat and kicked her. She died two days later from

the injuries she received at his hands. Jane was a young woman who had been in a relationship with James for several years. When he came to trial, their neighbours and friends recounted a history of threats and domestic violence by James towards Jane. Even though James Flood was convicted of her murder, the trial generated a number of news reports and ballads that emphasised her immoral lifestyle as the couple had lived 'in sin' at a house of ill repute. Although James was blamed for leading Jane into a life of vice, her tragic death was held up as a warning about where such behaviour could lead, combined with exhortations to women not to be led down a similar path. As such her murder at the hands of a violent partner became a morality lesson with no other examination of his behaviour.

Domestic violence and murders were not unusual. The same year that Jane was killed, the body parts of another woman were found scattered around the city. While such cases made the news there were huge numbers of violent acts against women that did not. The magistrates' court records for Norwich reveal a sad history of marital breakdown, much of it due to violence. Until the Matrimonial Causes Act of 1878, women's only legal recourse from a violent husband was to petition the magistrates for him to keep the peace against her, but a man could still ask the courts to order their wives to return home to 'bed and board'. The new act also meant women from all social classes could gain some legal protection from an abusive husband and obtain a judicial separation from local magistrates.

The vast majority of separations granted were on the grounds of persistent cruelty. At the Norwich Police Court held in the first week of October 1899 for instance, four married women applied for separations on those grounds. Each was granted, with their husbands ordered to pay weekly maintenance for their wives and children.

In July 1902, William Chapman was fined for assaulting Charlotte Chapman, while Elizabeth Margaret Sadler charged her husband Richard with persistent cruelty after eight years of marriage. In Elizabeth's case, the chairman asked her if she could live comfortably again with her husband and she

replied yes. At the same court, Sarah Eagleton of Globe Yard took advantage of the law by asking Norwich magistrates to grant a separation order and her husband of thirty years to pay maintenance. Her account of his years of violence makes for depressing reading. She had finally left him just over week before, after he 'smacked' her face, threw her on the hearthrug and kicked her, as well as kicking their youngest son. The defendant had terrified her by his language and had threatened to cut her throat. Neither would he work and had lived for some time past on the older children's earnings.

It was not a foregone conclusion that either of these women would be successful. However, the clerk pointed out that if the magistrates were not satisfied that a persistent case of cruelty against Sarah Eagleton had been made out, the summons could be amended, and the case could be brought forward on the grounds of neglecting to maintain his wife. The magistrates granted the separation order, the defendant having to pay Sarah fifty-four shillings a week, plus costs amounting to 10*s* 6*d*. In contrast, Daisy Stallon's request for a judicial separation at Norwich magistrates' court in April 1903 was dismissed by magistrates for lack of evidence of persistent cruelty by her husband, despite witness statements in support.

By the turn of the century it was easier for a woman to obtain maintenance if separated or divorced. Women such as the wife of Walter Thomas Minns in 1905 could also turn to the courts if the payments were not made. Nevertheless, for those who wanted to end a marriage the choices were very limited until well into the twentieth century. The Matrimonial Causes Act became law on 1 January 1858 enabling divorce without the need for a private act of parliament. This was extremely expensive and time consuming, and not necessarily successful. Not only that, but a man could divorce his wife on the grounds of adultery or desertion; until 1923, however, a woman also had to prove cruelty, or that her husband had committed bestiality, incest, rape, bigamy or sodomy. It was not unknown for a couple who wished to divorce to collude in presenting the

required evidence, but if that was discovered the case could be dismissed.

Before the 1858 Divorce Act, couples who wanted to end a relationship had few options. Some simply separated informally, while others chose either a formal separation or to have their marriage annulled. An annulment meant the marriage was declared as null and void, freeing each party to marry again as if for the first time. There were very strict rules on annulment, with for example, a husband or wife being able get their marriage annulled for non-consummation, but not for desertion.

Some couples that were already married and had formed other relationships embarked on what was known as the 'poor man's divorce' route. One undated broadsheet from the nineteenth century described the sale of a pretty young woman at Norwich market place to a gallant young fellow for one sovereign and a bottle of ale. This was promoted as an entertaining spectacle. Wife-selling was a long standing tradition and practice. Although variations occur it generally appears to have been seen as a common law means of ending a marriage. The exact origins of the practice are not known, and it was never recognised legally, yet there are numerous references to wife-selling in parish records, diaries, letters and newspaper accounts over centuries, with many of the rituals being very similar.

Even after divorce became more accessible, reports of wife-selling still appear up to at least the late nineteenth century. The sale usually took the form of an auction, often at a local market, to which the wife would be led by a halter. This was usually a rope, but sometimes it was a ribbon around her neck or arm. There is little doubt from many contemporary accounts that many of these sales were consensual agreements whereby both parties had formed new relationships. Nevertheless, not all such cases involved willing participants and the degree of coercion can never be known. What is telling is that was only the wife who was put up for sale as his property. No woman could sell a husband as no man belonged to a woman.

When Mary Jary Gurney was divorced by her husband on the grounds of adultery in 1860 after she left him for his groom, William Taylor, it was a scandal that made national headlines. Mary's moral character was called into question both in the divorce court and the press, and was a major factor in her husband being granted custody of their two children. Her reputation was damaged even further by reporters and the creators of scurrilous broadsheets rehashing the divorce scandal involving her parents forty-two years before. Mary was presented as being of 'bad stock' as her mother (also called Mary) had been divorced after her husband brought a prosecution against Richard Hanbury Gurney for 'criminal congress'.

This was also known as 'criminal conversation', and was a legal term used to describe an adulterous relationship between a man and another man's wife. A husband could sue her lover on the basis that a man's wife was his property, and the other man was therefore thereby alienating his wife's affections. Of course, there was no corresponding crime for a husband who committed adultery with a single woman.

Mary and William made a new life abroad, but unusually, she mounted a robust defence of her actions by publishing an 'Apology' in 1860, in which she partially blamed the marriage breakdown on them being cousins. The publisher of her apology went to great lengths to dissociate themselves from her actions, saying 'there can be no pardon nor extenuation for this great social crime'. Nevertheless, they felt her motives were worthy of consideration. Mary wrote of how,

> I have chosen between the universal condemnation of the world and my own sense of right; not in any sublime way, but in the simple, truthful way my nature craved. I lie down in the evening and rise in the morning, for the first time since a child, blessing God for my existence. Nothing can rob me of this now but death alone. I have that treasure to a woman's heart that a woman can alone understand – the open avowal of the love that controls her being.

Mary's lengthy account revealed how she tried to give up her lover and continue her marriage. She explicitly equated sleeping with her husband while in love with another man with prostitution:

> What had I accomplished? I had preserved the chaste name of wife. I had preserved the honor [*sic*] of my husband and the reputation of his children. And to do it, I was beneath his roof, and was about to submit myself to his embraces without love.

> For these considerations of honor and reputation, I was about to lead voluntarily a life of prostitution, distinguished from it only by the social fiction of a name, and I felt myself more degraded for this honorable hire than she who accepts her paltry dole in the streets.

Mary Gurney's Defence

The legal disputes over Mary Jary Gurney's divorce continued for several years. She was more fortunate than most women in her position as she was financially independent, having inherited

Part of Mary Gurney's Defence

a fortune from her father, which had been placed in trust so that no husband could have control of it. However, Mary tried to claim a share of the £2,000 that Mr Gurney had put into trust when they married for any children they might have, on the basis that she was still married to him when she had her third child. In 1863, the Court of Chancery declared that only the two children from their marriage were his legal heirs as there was no doubt that the third child was that of her paramour.

Little had changed when it came to women's moral character being taken into account when house-painter and former innkeeper Frederick Cadney obtained a divorce from his wife Sarah in 1901. When he applied on the grounds of her misconduct with their former lodger, Richard Dunham, witnesses were called in support. These included Mrs Cadney's landlord at Globe Yard where she had gone to stay, who described how Sarah was visited frequently by the co-respondent, and that they had spent time alone and acted like a married couple.

When the Cadneys' divorce was granted, Frederick was given custody of their two children. He remarried a year later, and their children continued living with him. Sarah and Richard moved in together and had three children by 1911, who were variously named as Cadney Dunham, or Dunham Cadney. They never married, and made attempts to cover up their relationship on official documents. When they were recorded on the 1901 census Sarah was noted as Richard's housekeeper. Ten years later she was his lodger and noted as single and there was no explanation of how their two surviving children were related to either of them.

Sarah Cadney's divorce illustrated one of the major barriers against women seeking a divorce because women had no rights to custody of children once they were over the age of 7. While many men did not seek custody for a variety of reasons, including practical ones relating to childcare, a woman's 'immoral' behaviour could, and was, used against her. It was not until 1925 that the practice of automatically granting custody of children over the age of 7 to their fathers was ended, and it would be nearly another fifty years after that before custody rights were equalised.

Divorce was still very expensive and difficult to obtain. As a result, cohabitation and bigamy were common as people came up with alternatives. In Emma Ashlee's case, her husband, Henry John Fryer, married her at Norwich St John de Sepulchre church in 1895, seven years after his first wife had left him, but he claimed to be a widower. Statements made by both parties in court indicate that she may have been aware that their wedding was not legal for some time, but only reported him for bigamy after an argument. The vast majority of cases that made it into court relate to men having more than one wife, but an exception was 27-year-old Elizabeth Yeomans in April 1851. She was sentenced to fourteen days' imprisonment for having married John Mapes the previous December at St Peter's Mancroft, despite her husband, Carter Yeomans, still being alive.

Women who had children without being married faced particular obstacles. There was an accepted sexual double standard. This was partly based on long-standing religious beliefs and moral attitudes which promoted purity before marriage (particularly for women). This in itself was partly due to a desire by men with property and titles to be sure that the children borne by their wives were really theirs. Such attitudes had filtered down from the higher classes in society.

Although population studies reveal that large numbers of couples were expecting a child when they married, as well as significant levels of illegitimacy in all time periods, there is little doubt that there was tremendous stigma against illegitimacy. The majority of women who had illegitimate children and survived the birth still went on to marry someone (sometimes the father of their illegitimate child). This combined with the fact that most people married before their first child was born, the low numbers of identifiable cohabiting couples, cohabitees passing themselves off as married, and the prevalence of bigamy indicates that marriage was seen as the norm. Despite the hypocrisy of many of the social and political elite in society when it came to their own personal lives, illegitimacy and cohabiting were generally considered immoral. Religious and legal sanctions existed, and pressure was put on people to comply with or at least pay lip service to prevailing moral guidelines.

Many women who had illegitimate children either when single, separated or widowed, went to great lengths to cover up their situation by either abandoning their children, or worse, committing infanticide. After the husband of Charlotte Minns (née Ward) of Ber Street died in 1932 she was left with three children, one of whom was born six months after his death. Four years later she had another child. Although she did not go so far as to name her deceased husband as his father on the birth certificate, she did when she had him baptised at the church of St John de Sepulchre a month later, and continued with the pretence on other official documents such as his school records. Charlotte was able to survive on her husband's army pension and taking in lodgers without having to claim poor relief.

At least by 1850, women were no longer being required to make a public penance for immoral behaviour by having to stand in church and publicly declare their sins to the congregation, while asking for their forgiveness. Few, if any, of the records of such public penances in parish registers mention the men involved.

Many women who did not marry faced huge financial hardship if the father was unwilling to pay or defaulted on a bastardy order. Even if they had family willing to help, if they were unable to work around the time of the birth, then they might have to enter the workhouse or a mother and baby home. Maria Brown, a single woman of Globe Yard was just one Norwich woman who resorted to the courts to make the father of her illegitimate child support them financially. After her child's birth in October 1882, the magistrates ordered William Flaxman to pay two shillings a week until the boy was 14. Nine years later she had to take him to court again for non-payment.

It was not uncommon for a single or widowed pregnant woman in that situation to marry a widower who needed help with his own young family. While many of these marriages were love matches, there were undoubtedly large numbers that began as practical arrangements.

Living together and/or having children out of wedlock were still vastly disapproved of. Many couples went to great lengths to pass themselves off as married. Some women and men simply applied the 'seven year rule', assuming that their husband or wife was dead if they had not been heard of for that length of time. When Laura Holmes of Norwich formed a relationship in around 1901 with a married man who was separated from his wife, they passed themselves off as married on passenger lists when they emigrated and on their daughter's birth certificate. The only document in which the truth was recorded was his will, in which he ensured that Laura, their child and his legal wife were taken care of financially. After his death, Laura returned to England and left her child to be brought up by her parents. When she died she was recorded as using both her own name and his surname, but such was the stigma around her

relationship and circumstances of her daughter's birth that her grandchildren were told she was a great aunt.

The twentieth century saw far more progress towards legal equality once married, as well as making it easier to leave a husband if desired. Some of the restrictions on marrying close relatives such as in-laws and step-relatives were lifted. However, there were still some anomalies, with men being able to marry a deceased wife's sister from 1907, but, bizarrely, women not being able to marry a deceased husband's brother until 1921. Many couples who fell afoul of these rules chose to wed in churches outside their own parishes or a register office in order to get around the obstruction. However, there were large numbers who simply lived together – often pretending to be married – until the law changed and they could legitimise their union. Some of these couples also took advantage of an Act passed in 1926, which meant that any children born prior to a marriage could be re-registered as legitimate if their parents married after the birth.

Another major change for women occurred in 1929 when an age of consent for sexual intercourse was introduced for girls, and the age at which people could marry was raised. Until then it was still possible for girls to marry at the age of 12 and boys at 14, although it did require a special licence. The age of consent was introduced after a long campaign against child prostitution and exploitation of young girls, with the result that the age at which a girl could marry had to be changed too.

Such was the desirability of being married over the fear of being left on the shelf, that a broken engagement could lead to a court case for breach of promise. If a woman had a sexual relationship with a man after he had promised to marry her, and he then broke it off, her only option was to ask for damages for the loss of her reputation. This did, however, mean that personal details of their relationship were aired in court, which might damage her reputation even further. The grounds for defence were often based on proving she was not a virgin when they met, or had slept with other men.

A typical case was that of Alice Tooke of St Augustine's in the city, who successfully brought a case against Edward

William Gunn for improper conduct in the summer of 1888. The couple had met at a fete two years before and her solicitor described how 'billing and cooing went on for some time'. Around twelve months after he proposed marriage, she noticed a coolness in his manner. Shortly afterwards he claimed he had heard she was subject to fits and he therefore wished to break off the engagement. His love letters were presented in court as evidence, and it emerged that he had in fact met someone else. Alice was compensated for loss of earnings because he had persuaded her to give up her situation, the slur on her reputation in relation to the claim about fits, as well as the expenses involved in preparing for the wedding and purchasing items for the household.

Miss Grace de Lacy, a cinema attendant of Bury Street was another who took this step in 1933. She asked for financial compensation from her ex-fiancé, George Watson, for linen and cutlery she had bought in anticipation of the marriage. These included eggcups, a tea strainer, tin opener, two cake tins and a pastry cutter. Unfortunately for Grace, the judge ruled that she had bought the goods long before any marriage plans were made and that it was an obvious attempt to obtain money from the defendant.

Women began to have more personal freedoms and legal rights in the twentieth century, which meant that a growing number were less reliant on men for financial security. However, vast numbers had little alternative but to stay in a marriage even at risk to their own lives. Moreover, marriage was still seen as the ideal state for a woman, with single women looked down on. Nevertheless, as the century progressed, matters began to improve little by little. This was, in part, influenced by the significant number of women who had never married between the two world wars because women outnumbered men. Many had also lost sweethearts during the First World War. After the end of the Second World War, the number of people marrying increased significantly, but so did the number of divorces.

Yet, the double standard still prevailed in 1950. The hurt caused to a man's feelings if his wife committed adultery was

still recognised by divorce courts in a way that did not apply to women. So when Eric Iddiols divorced his wife Vera in 1948 he was awarded damages of £150 from her lover, Donald Hayden of Norwich. Although matters had improved significantly for women legally by 1950, it would be 1969 before people could divorce just on the grounds of marital breakdown. It was a further eleven years before the Domestic and Matrimonial Proceedings Act in 1970 gave women legal protection from abusive husbands.

Maternity and Health

Having children was hazardous. Until within living memory, women prepared themselves spiritually and practically for the very real possibility that they could die. When Emily Webster's grieving husband posted a death notice after she died in childbirth in Norwich in 1870 at just 22 years old, the cause was so commonplace that it would not have raised any eyebrows, or even required an inquest. Being the wife of a surgeon-dentist with the financial means to pay for medical care had not saved her.

Until well into the twentieth century, the most common causes of death for a new mother were loss of blood or puerperal fever. Childbed fever, as puerperal fever was known, was mainly caused by birth attendants not disinfecting their hands with chloride of lime, thereby transferring bacteria from one patient to another. The body went into toxic shock in reaction to the infection.

As well as infection, inquests and causes of deaths recorded on death certificates indicate the other major causes of death for mothers was poor nutrition and inadequate medical care. While poverty increased the risks significantly, bearing lots of children within a short span of years and the demands of raising large families ruined the physical and mental health of numerous women from all social classes. In 1888, out of 127 deaths in the city for which inquests were held, 6 of the causes of death given were from childbirth and 14 from puerperal fever.

Even if the mother survived childbirth, the percentage of mothers outliving their children was enormous, with infant mortality a horrendous problem. The eighteen wives and widows listed at Globe Place off Heigham Street when the 1911 census was taken had given birth to 104 children between them, of whom only 80 were still alive. Annie Betts and her husband Daniel had been married twenty-three years and lost two out of seven children; the widow Elizabeth Lawrence had one son and one daughter left out of five children; Florence Brown was 35 years old and had lost six out of the nine children she had given birth to during her fifteen-year marriage to William; Ella and Francis Wacey had two children die out of their five; Mary Howard still had nine of the ten she had given birth to by the time she was 39; Eveline and James Goodbody had lost one child out of a total of six; Amelia Elizabeth Earley had given birth to twelve children in sixteen years by her husband William, of which all but one were still alive; Ellen Elizabeth Browne and her husband Albert had lost five out of their eight offspring, while nine out of ten of Elizabeth and Samuel Marrison's children had survived.

None of these figures include miscarriages or stillbirths. Neither were the number of children born out of wedlock, or during a previous marriage, included in the statistical gathering undertaken by the census enumerators.

Lack of training among midwives and access to good medical treatment undoubtedly played a part, as did poor nutrition and insanitary living conditions. The existence of an infirmary in a workhouse increased the number of women going into a workhouse to have children. Although workhouses were only required to have one from 1867, Norwich's workhouse opened with an infirmary in 1859. This meant that the poorest city women had more access to healthcare than those in some of the county institutions. A large percentage were those having illegitimate children, but there were many married women too as it provided the only free healthcare outside of charity organised schemes. This included general medical care, while all children in workhouses were vaccinated for smallpox many years before it became compulsory for the whole population.

However, while they might have access to a nurse and doctor, this did not alleviate the impact of poverty on women's health. The levels of maternal and infant mortality were exacerbated by poverty. When the Norwich District Visiting Society made its annual report in 1858, it noted how it distributed around £500 annually among a population of 70,000 persons in the poorest districts. This took the form of presents once or twice a year of essential household items such as a sheet, or a shilling's worth of coals or bread, with particular attention given to those families where a child had recently been born. As late as 1907, the city coroner highlighted how a young married woman had died after childbirth due to lack of proper nourishment as her husband was out of work.

The quality of care for pregnant women varied enormously. Cases of death due to neglect, malpractice and ignorance on the part of midwives and doctors were not unusual. It would be too simplistic to say that inadequate treatment was solely down to lack of training as coroners' inquests reveal that many doctors and women with training were censured for deficiencies, neglect and malpractice. As a result, the newspapers between 1850 and 1950 are full of sad cases of women dying as a result of complications during childbirth, or from an infection afterwards. Sadly, many were due to, or exacerbated by the actions of midwives and doctors. The majority of women from all social classes gave birth at home. For the poorest women in Norwich the only help available was via the workhouse or charities.

When Norwich woman Ann Minter died on 27 April 1868 due to neglect during childbirth, an inquest was held which revealed some of the problems that poor women faced in particular. Mrs Martin, the midwife, had not sent for a doctor for several hours after it was evident there were problems with the birth, nor arranged for Ann to be taken to the workhouse infirmary. Mrs Martin had been a midwife for twenty-eight years, and in her statement to the court, said she had not sent to the doctor straight away as she did not think he would attend without an order from the relieving officer. Without such an

order the doctor would not get paid. Neither did she make arrangements for Ann to be taken to the workhouse infirmary as she had received verbal instructions to only do so for women unable to pay for a midwife during the daytime. If they went into labour at night the midwife must do the best she could. The guardians of the workhouse and doctor refuted that this was the case and Mrs Martin was strongly censured. Nevertheless, the claims and counterclaims all painted a picture of how a young mother's care was compromised by financial fears and ignorance about what free care did exist.

The lack of medical expertise among birth attendants was a major problem. When Elizabeth Marshman of Adelaide Street died nineteen days after giving birth in July 1865, the circumstances caused a great deal of talk in the district. An inquest was held into the actions of the male midwife, Mr S. Matthews. Witnesses described how Elizabeth had a very severe labour, the child being unusually large. Exhausted and unable to deliver the baby without assistance, Mr Matthews used forceps with much force. After also hearing the opinions of surgeons who examined Elizabeth before and after her death, the coroner found the cause of death was due to difficult birth and labour, coupled with great want of care, skill, and judgement on the part of the male midwife.

In another case, Sarah Martin of Caroline Yard, who had been a midwife for over twelve years, was sentenced to six months' imprisonment in 1871 for manslaughter after being accused of causing the death of Sarah Tooke through drunken carelessness.

Care for pregnant women improved significantly after the 1902 and 1905 Midwives Acts were passed requiring all midwives to be qualified and registered. It did allow unqualified women to act in an emergency pending the arrival of a doctor or registered midwife, but was controversial as many experienced midwives who had learnt their skill from other women felt it deprived them of both work and their status. After one case in 1902, a local coroner went so far as to state that he believed an experienced midwife with no certificate was as good as a

certificated one. Around 80 per cent of midwives had nursing training by 1920, but the cost rose along with standards. Many poor women still had to take the risk of using unqualified woman and hope she was experienced enough as they could not afford to pay for one that was.

Every year in the early 1900s ten qualified midwives attended roughly 2,500 births, one-eighth of these at the maternity charity home. The Norwich Lying-In Charity was one organisation that tried to fill a need. Founded in 1832, with the purpose of ensuring children were brought into the world safe and sound, it provided midwives for married women giving birth at home. It had no premises then, but paid the matron £5 a year with an additional 10s for each time she used her own home to deliver a baby, or when the committee met there. Two years later it became known as the Infirmary for the Diseases of Women and Children. From 1840 onwards they rented various premises. The charity raised the money to buy its first home on St Benedict's Plain in 1883, at which time it had 500 patients. It pre-empted national legislation by deciding in 1893 that only certified midwives would be employed. In 1894, it became the Norwich Maternity Charity with qualified midwives attending over 500 births each year. After the 1902 and 1918 Midwives' Acts it was the obvious base for local services and it effectively came under municipal control in 1919.

As the years went on, more and more training requirements were added in order to ensure mothers received the best possible care. Despite the diminishing birth rate there was still a great call on its services, and by 1902 it moved to Bethel Street and changed its name to the Norwich Maternity Charity. The following year, the charity oversaw 513 births, with no deaths.

By 1910 nearly 800 women a year used its services, the vast majority were poor women who could not afford to pay for a midwife or doctor; the charity obtained new premises for a maternity home the same year. When the new home opened it was able to boast that although the population had risen by 15,000 in the previous ten years, the incidences of puerperal fever had fallen by 75 per cent due to increased skill and

cleanliness. They also commented on how local health visitors had recommended a large number of badly nourished mothers to the Norwich Sick Poor Society, whose assistance contributed to lessening infant mortality. This charity had been set up in 1818 to provide money, goods or medical aid to 250 women. By the end of the century it was assisting over 1,200. The Lying-In Charity also provided a model for the Norwich District Nursing Society, which employed six nurses in 1900, and for municipal health visiting from 1907. That year, the city's public health committee appointed two health visitors to monitor infant welfare and dangerous diseases.

In 1919, the city council took control of midwifery services and began to send pregnant women with complications to the hospital. Ten infant-welfare centres offered antenatal clinics, baby care advice and monitoring of children up to the age of 5. This, along with a pure milk municipal depot and vitaminised milk for babies, helped reduce infant mortality.

Annual reports of Medical Officers of Health in the late 1930s revealed that at the end of the nineteenth century infant and maternal death rates nationally had been between 170 and 180 per thousand. By the late 1930s this trend was, fortunately, in decline. In 1937, it was fifty-nine per thousand, and in Norwich this figure was down to fifty-two. The Ministry of Health declared that the number of women dying in childbirth was the lowest for fifteen years.

A tribute to the improved standards occurred in 1949 when city corporation midwife Hilda Robinson celebrated delivering her one thousandth baby in the eleven years since the Domiciliary Midwives Service began in June 1937. Even after the introduction of the National Health Service in 1948, the majority of births took place at home, and only transferred to hospital if they had something wrong. Instead, the Norwich community midwives who followed in the 1950s, such as Phyll Clements, boiled syringes for reuse and made their own cotton-wool swabs by baking pieces of cotton in an oven before setting off to deliver babies, carrying cylinders of gas and air on the backs of their bicycles.

Giving birth and after-care were not the only problems facing mothers. Constant childbearing and unwanted pregnancies, for whatever reason, created physical, mental and financial burdens. However, preventing having children or ending a pregnancy was problematic until well into the twentieth century. It is virtually impossible to know how many women took birth-control measures, or deliberately ended an unwanted pregnancy. Anecdotal evidence, oral histories, diaries, letters, the widespread advertisements of pills and potions for female 'problems' and 'irregularities', oral histories, inquests and medical reports indicate that contraception was widely used, if often ineffectual. While many unmarried women who found themselves 'in trouble' undoubtedly resorted to abortion before it was legalised in 1969, so did large numbers of married women who already had children.

Many women who had miscarriages found themselves suspected of inducing an abortion, especially if they were single or had marital problems. There was also a presumption for much of this period that if a woman's illegitimate child was stillborn, died soon after birth, or she had a late miscarriage, then she could have deliberately caused it to happen. Numerous bodies of babies were found buried or floating in a river, such as the female child found wrapped in a piece of calico in a garden on Unthank Road in 1861. While some were undoubtedly murder victims, others were not. In many cases, when the mother was traced she claimed to have not known she was pregnant, or to have simply feared the consequences when her child was born dead, or died soon after the birth, and subsequently tried to hide what had happened.

This was the case with Charlotte Mack of St Stephen's parish who was investigated for infanticide in 1858, after the body of her illegitimate baby was found. Having heard there were no preparations made for the birth, the coroner questioned witnesses, including neighbours, her sister and mother as to her behaviour and state of mind in order to establish if Charlotte could have deliberately caused its death. In the end she was charged with concealing a birth, and eventually acquitted after six months in jail.

There were many cases where a post-mortem was carried out because the mother was single, as occurred with Louisa Taylor in 1862, even when the birth was not concealed. Having gone to her local sexton to request a burial she told him the child was born alive, but died soon afterwards. He informed the coroner and Louisa was investigated for infanticide. In this case she was given the benefit of the doubt by the coroner and the charge was dismissed, although not before intimate details of her life were revealed in local newspapers.

By the early 1900s the use of contraception had increased. The average number of children in a family had been 6.1 in the 1860s, but had dropped to 2.6 by the 1910s. The first family planning clinic in the UK was founded by Marie Stopes in 1921, but in 1922 maternity clinics were banned from giving out information on contraception. While middle- and upper-class women could obtain assistance by paying privately, this was not an option for the vast majority of women. The following year, the Labour Women's Conference voted in favour of providing birth control information to everyone. It was a campaign in which Norwich's first female MP and political activist, Dorothy Jewson, was actively involved. She formed part of a delegation to the Health Minister in 1924 demanding that Ministry of Health organisations should give advice on birth control to those who asked for it, and for doctors at medical centres to offer advice in certain cases.

Dorothy co-founded the Workers' Birth Control Group with Dora Russell in the same year in an attempt to make it possible for working women to obtain safe and free birth control information and treatment. When Dorothy was still an MP she managed to raise the issue in a parliamentary debate and pointed out that the health of many working-class women had been destroyed by multiple pregnancies, leaving them physically unfit for further pregnancies, or to bring up healthy children. However, they could not obtain information about birth control from welfare centres, whereas upper- and middle-class women with the means to pay could obtain the necessary information from a private doctor.

Dorothy Jewson paid the price for her support on this issue by losing her seat at the next general election, as her share of the vote was affected by ruthless and explicit campaigning by Norwich clergy against her over her support for family planning. Nevertheless, she did not give up. She constantly lobbied for birth control to be available to all women, especially working-class women who needed it most, arguing that it was more important to women than housing or food prices. The issue of contraception was still controversial in 1928 when Dorothy attended the Women's Conference at Brussels, in association with the Labour and Socialist International movement. She was the only Englishwoman to speak for the right of poor women to knowledge about birth control, and fundamentally, in favour of freedom of choice in motherhood. One of the delegates commented that they would not have been allowed to attend by the men in their lives if they had known birth control was going to be discussed. Dorothy continued fighting for access to free birth control and improvements that would benefit women's health alongside her other political activities for the rest of her life.

In 1930, the Ministry of Health allowed local health authorities to provide birth-control advice to married women if a further pregnancy would be detrimental to their health. Seven years later, the local health authorities were encouraged to establish post-natal clinics which also provided contraceptive advice due to concerns over maternal mortality.

Although having fewer children was undoubtedly better for women's health, the falling birth rate in the twentieth century caused some concern. In 1939 it became the subject of a debate in the House of Lords, whose all-male assembly were so alarmed that it was suggested family allowances should be paid directly to mothers in order to encourage women to have more children. Fortunately, their worries did not affect the continuation of existing services, although they were still aimed only at married women.

Nevertheless, women such as Phyll Clements who grew up in the 1930s and 1940s can recall huge levels of ignorance about the facts of life and contraception among her friends,

neighbours and family. The Norfolk school she went to in the late 1940s caused immense controversy when it became the first in the county to teach sex education. Working as a midwife in Norwich from the 1950s onwards, she still came across mother after mother who had little or no control, or knowledge, over the number of children they had, nor how to prevent a pregnancy occurring.

When the National Health Service was established in 1948 it did not include any provision for family planning services. Women in Norwich and elsewhere were still reliant on being able to pay for private help such as the Norwich Women's Clinic which opened on Ber Street in 1950. Married women could see a female doctor and a nurse for practical advice on contraception on one of the three afternoons and one evening a week it was open. Although it was supported by voluntary contributions, women had to pay a consultation fee of 2*s* 6*d*. It was only in 1952 that family planning clinics began to give contraceptive advice to women who were about to be married. It took until 1967 for such information to become available to all women regardless of marital status. For women such as Phyll Clements the availability of the contraceptive pill in the 1960s was a miracle.

Mental health problems also adversely affected women, with a number of conditions specific to women that resulted in them being confined to an asylum. The Bethel Hospital set up by Mary Chapman in the early 1700s was the first purpose-built asylum in the country. It was run by a charitable trust, and in the nineteenth and first-half of the twentieth century it fulfilled its founders' aims of providing a progressive and caring approach to its residents. By 1931 it housed 128 people. In 1948, it became part of the National Health Service as an annex to Hellesdon Hospital.

The admission registers and case files from the city and county asylums reveal that large numbers of women were admitted due to what is now known as post-natal depression. Asylums had become more widespread across the country after 1845 when it became compulsory for each county to provide

them. A study by Julie Jakeway into female patients admitted to the county asylum in Thorpe between 1846 and 1870 reveals that the majority of women were admitted due to puerperal mania, childbirth and lactation. Other causes included menopause, grief, poverty, fear of poverty, disappointed love and the birth of an illegitimate child. The admission registers and case files from Hellesdon Hospital for the nineteenth century evidence the same pattern. Both institutions pursued a course of treatment that included hygiene, work and exercise. Work was seen as therapeutic as it helped prevent patients from dwelling on their problems, with female patients being put to work in the laundry, as cleaners or with needlework.

Many women's mental health was eroded by exhaustion, poverty and poor housing conditions. As a result, being fed properly and having a rest went a long way towards alleviating their symptoms. When 60-year-old Emma was admitted to a local asylum in 1855 suffering from mania caused by starvation, her case notes record how, after two good meals, she became calm and talked rationally. Eighteen months later she was well enough to be discharged to the care of friends. In another case a young widow named Rachel had suffered a breakdown due to an unhappy relationship with her parents, anxiety over her child and dread of starvation. She was discharged as cured after two months.

Not all women were so fortunate. Elizabeth Davis of Palace Yard, Barrack Street, drowned herself in 1899 after being released from the city asylum where she had been confined for several months. The coroner criticised her husband for not returning her to the asylum after she began to decline again, and doctors had advised him to. Alice Maud Mary Sewell of West End Street was just one of the many women who took their own life after suffering from post-natal depression in 1902. This was despite having been considered cured after three months in an asylum.

Women's health issues were not confined to pregnancy and having children. Neither can poor health be separated from the issues of poverty and poor housing. A woman's ill health could

have detrimental effects on the family as a whole. Moreover, it was women who bore the brunt of health problems generally as the primary carers of others.

If a worker became ill before the twentieth century they had no legal right to maintenance from an employer. The women labouring in Norwich shoe factories, dye factories, shops and laundries, as weavers, seamstresses and domestic servants, or as washer women and piece-workers at home, were at risk of serious health problems through working in hot, humid and dangerous conditions. Long hours and hard physical labour also took its toll on girls and women working up to twelve or fourteen hours a day. This was despite the efforts of benevolent employers such as Colman's Mustard factory, who employed the first industrial nurse in England.

While the various factory acts and other government measures, such as the introduction of female welfare superintendents and inspectors in the early 1890s gradually improved matters, it was a slow process. There were still many unregulated industries at the beginning of the twentieth century. However, despite having access to doctors, nurses, pills and potions, the health of many middle-class women was not much better than that of working-class housewives. For those who spent the majority of their days inside poorly ventilated houses heated by coal fires, one the biggest causes of death was respiratory problems.

Until 1948, the ability to access medical care was dependent on a person's financial situation, while the quality of what was on offer varied enormously. Norwich has a long tradition of charitable foundations aimed at providing medical care. The Great Hospital on Bishopgate founded in the thirteenth century catered for the aged and infirm. In 1850, the average age of people living there was 75. The women living there when the census was taken the following year were aged between 66 and 89 and had worked in a range of occupations from servants, silk weavers and housekeepers to staymakers, shawl makers, a greengrocer and tailoress, as well as one actress and a former dresser to Princess Charlotte. Many of the women were recorded as blind, partially blind, deaf, physically disabled or

suffering from some kind of dementia or mental disability (categorised as 'lunacy' or 'imbecility') on census returns and the hospital's admission registers. Doughty's Hospital, which began in the seventeenth century, gave a home to a small number of women and men over the age of 60, with forty-two residents there in 1869.

The most ambitious project was the Norfolk and Norwich Hospital, which was a charitable institution founded in 1798 for the poor and the sick. It was extended over the years and had 220 beds by 1914. Until the establishment of the NHS it was dependant on bequest and fundraising to provide facilities. In 1907, the hospital introduced charges for outpatients, which was extended to inpatients in 1921, although a weekly contributory scheme was set up that ensured contributors and their dependants did not have to pay. By 1923 around 70 per cent of inpatients were in the scheme, a figure that had risen to 80 per cent in the 1930s.

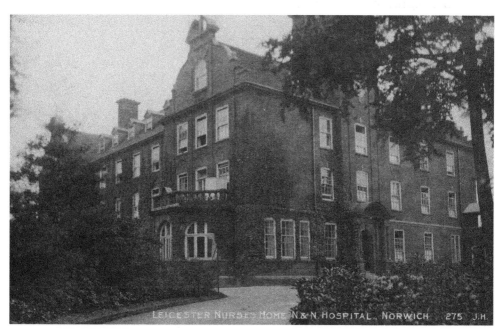

Leicester Nurses' Home at the Norfolk and Norwich Hospital

Elsewhere in the city was the Jenny Lind children's hospital, the second dedicated children's hospital in the UK. It was set up in 1854 and named after the Swedish singer who gave fundraising concerts on its behalf. It not only provided inpatient and outpatient healthcare for children, but was proactive in providing health education to parents. Over just one five-year period between 1875 and 1880, it had treated 3,000 children. Its resident medical officers in the 1890s included Drs Lucy Muir and Mary Bell, who were among the first female health practitioners in Norwich.

The Norwich Homeopathic Dispensary, which was set up in 1852, offered another alternative. Despite controversies over the treatments offered, it remained immensely popular for decades. There was also an eye infirmary, which had been founded in 1822, and had over 150 patients a year by the early 1900s.

An invaluable source of primary care in the city was the Norwich Dispensary, whose medical officers diagnosed illnesses and prescribed medicines. As a charity it struggled to

Jenny Lind Infirmary

raise enough funds and faced obstacles from local practitioners who feared losing paying patients. Eventually, in 1880 it was reorganised on a provident basis whereby monthly contributors could access medical care. By the early 1900s it had over 30,000 patients, but the compulsory health insurance scheme of 1911, which offered sickness benefit and GP services to manual wage earners, eroded its client base.

Although Norwich saw a great deal of improvement in medical care in this period, the city suffered several epidemics of smallpox and cholera. In 1853–4 there were 223 deaths from cholera. In the 1870s, it had the second largest number of deaths from smallpox out of seventeen large towns. The health reports from this era reveal that other infectious diseases such as scarlet fever, measles, mumps and diphtheria were rife, while child mortality rates were well above the national average. In 1914, Norwich was reported as having exceeded the national mortality averages due to the high number of infant deaths.

There was no officer of health in Norwich until 1872, and even then they were part time until 1925. The poor quality housing across much of the city affected peoples' health, with only 30 per cent of houses having effective systems for getting rid of waste and sewage by the early 1900s.

By 1900, the Norwich Workhouse was overwhelmingly used for the sick, aged, infirm or mentally ill. Most of the 170 infirmary patients were described as feeble. Although the number of beds were reduced over the next three decades the female ward still had room for 117 beds in 1925. Another block was opened in 1939, and the need for it to be used for general use by the public during the Second World War led to it being taken into municipal control. From 1941 it was known as Woodlands Hospital before it became the West Norwich Hospital.

The 1911 National Insurance Act compulsorily extended health insurance to most male manual workers, formalised arrangements with approved societies such as Friendly Societies, trades unions, the Co-operative Society and private insurance schemes. However, it was resented by many doctors to begin with as they were unsure it would benefit them financially.

Their concerns were assuaged as time went on and it became evident that the scheme made their position more secure.

Until the introduction of state health insurance there was extensive membership of friendly societies in Norwich, which provided financial assistance to members and their dependants if sick or unemployed, and annuities in old age. There were not as many friendly societies specifically aimed at women as for men, but in 1853, the Norwich Female Friendly Society reported that they supported 132 women, with an average age of 82. Their report added that since the society had been formed just over fifty years previously, over £13,500 had been distributed among members for sickness, childbirth, the death of husbands and in annuities.

The Norwich Friendly Societies Medical Institute had 7,550 members by 1936. At least half of all adult male workers were making some provision against sickness by the 1940s, although there was less provision for women and families, who were also the most likely to be inadequately nourished and living in accommodation that was detrimental to their health. One local insurance scheme which began in 1914 had over 42,000 people registered in its first year. It expanded rapidly, but could not cater for all who needed treatment. There were only limited specialist beds for tuberculosis patients for instance. Hospital, charitable and Poor Law medical care filled in many of the gaps, but not all. In addition to which, many people were deterred from seeking help from such organisations by the stigma involved in doing so.

Emergency measures were put into place during the Second World War to make sure that health services did not collapse. As a result, hospital care was funded by the state. As well as normal patient facilities they had to deal with civilian injuries during bombing raids. This provision was maintained until the post-war National Health Service (NHS) came into being in 1948 with its tax-funded, nationalised hospitals.

The new National Health Service and Welfare State meant that women no longer had to worry about paying for a midwife or doctor, or having to go into the workhouse to

obtain medical care. There were still restrictions on accessing contraception, with provision being aimed at married women. Illegal abortions also continued to be commonplace as did women having to put children into care or give them up for adoption for a whole host of reasons, from the stigma of unmarried parenthood to inability to take care of them.

Women such as Phyll Clements remember the NHS as absolute heaven, especially as they had not believed it would actually happen. She recalled how people almost expected to die if they became seriously ill because they could not afford proper care. 'One day we had to pay, the next day it was free. It was magic.'

Poverty and Housing

Poverty

When Rebecca Dewhurst from Norwich and her three children were abandoned by her husband in 1876 in the Todmorden area of Yorkshire, where they had been living, she returned to Norwich where she still had family. Unfortunately for Rebecca, she could not support herself and ended up in the city workhouse on Bowthorpe Road. Perhaps even more unfortunately, she was promptly removed to the workhouse in Todmorden as her husband had a settlement in Yorkshire. As a married woman she belonged to the same place as her husband and was therefore his financial responsibility, regardless of where she was born or might have worked.

Poverty was a regular fact of life for a large percentage of the population, particularly before the introduction of the Welfare State in 1948. Until 1834 poor relief had been the responsibility of local parish officials as each parish was responsible for its own poor, sick and elderly, with the costs being paid out of local taxes. People were only entitled to relief from a parish to which they had a settlement (belonged), and that depended on whether they were born there, or earned it through a variety of criteria, including work and having paid rates. The system for assessing settlement was particularly harsh on married women who had been widowed or abandoned as all married women automatically took their settlement from their husbands.

The 1834 Poor Law Amendment Act transformed the system for providing poor relief, by organising English and Welsh parishes into Poor Law Unions. Each had its own workhouse administered by elected Boards of Guardian. The main difference was that groups of parishes formed a union which was responsible for the paupers in their district, rather than individual parishes. For women such as Rebecca Dewhurst little changed, as the criteria used to determine which union was responsible for maintaining paupers was based on the old parish rules. Although a workhouse union could make an arrangement with another union over maintenance payments, it was not unusual to see women like Rebecca being removed from where they were born, or had family connections, to the place their husbands belonged, even if they had never been there themselves.

The underlying principle behind the new Poor Law was that those capable of work should work, otherwise they had to endure the disgrace and subsistence. The provision of poor relief was influenced by Benthamite ideas of utility and efficiency. Poor relief was now to be granted only to the able-bodied poor and their dependents within an efficiently managed workhouse. It was believed that by making life in the workhouse as off-putting as possible, it would encourage a responsible work ethic so that only those in most need would use it. The result was that poverty became seen as a social disgrace so awful as to be almost criminal, with only the sick, elderly and disabled not responsible for their misfortune.

Conditions for the inmates were deliberately designed to be harsh and inferior to life outside for even the poorest in society. Even the physical design and location of workhouses was meant to be forbidding. Out-relief in the form of small sums of money and/or food and fuel continued to be provided to those unable to work through no fault of their own, mainly the elderly or sick. However, this was limited, so that long-term illness or care provision usually resulted in admittance to the workhouse. The irony was that inmates were not meant to be better off in any way to those outside, but the diet of the very poorest meant that regular workhouse meals were a vast improvement for a great number.

Poverty stricken women such as Rebecca Dewhurst who were abandoned, or left a husband, were also affected by their legal status as 'belonging' to a husband. When the union workhouses were established, they continued the practice of removing paupers to where they 'belonged' if they ended up living somewhere else. This was because each union was only financially responsible for those that had a settlement in their area. In practice, this meant removing someone from one workhouse to another unless some kind of financial agreement could be made. Deserted wives were rarely given out-relief – financial aid in their own home – so they had little choice but to go into workhouse if they could not support themselves. In Rebecca's case she was reunited with her husband and they went on to have more children in Todmorden, but it is impossible to know what influenced that decision.

Ellen Green (née Plunkett) of Globe Yard in Norwich was typical of many women forced to apply for poor relief after her husband Richard left her in November 1879, following a fight with her brother for which he was charged with assault. Ellen managed to keep going until the following March with the help of her family. It took until January 1881 for the Guardians of the Poor to catch up with Richard in Hackney in London, at which point he was ordered to reimburse the authorities the £6 13s 1d they had given Ellen for poor relief, including school fees for the children. She was also able to stay in her own home rather than having to go into the workhouse. By the time the census was taken a couple of months after the court case, Ellen had moved with her children to Old Crown Yard in the parish of St Martin at Oak and was working as a shoe-fitter, as well as taking in a lodger to help with costs.

There was little alternative for the majority of elderly people in Norwich who were poor, apart from the Great Hospital and Doughty's Hospital. Both of these had begun their lives as almshouses funded by charitable donations. Doughty's was founded in the 1600s, whereas the Great Hospital on Bishopgate dates back to 1248, and is unique, in that part of the accommodation was constructed inside the church of

St Helen. In 1929 it had sixty-seven female residents alongside the couples and single men. In the same year, the Doughty's Hospital residents were noted as receiving thirteen shillings a week, including their government old-age pension, as well as coals, light, laundry, nursing, medical assistance, and clothing every two years. Both organisations still exist as charitable trusts offering sheltered accommodation and residential care.

Some Norwich women were helped by guilds or trade associations relating to their husbands' work, especially if the men had been apprenticed to a trade in the city. Others had fathers or husbands who contributed to friendly or cooperative societies. The Co-operative Women's Guild was set up in 1883 to provide women a voice within the movement. When the Norwich society's annual meeting was held in 1888, Mrs B. Jones spoke out in favour of how co-operative wives and daughters being involved could improve both the co-operative movement, and the women's own lives through education and unity. This was reiterated at meeting after meeting, such as the first annual outing of the Norwich Co-operative Society in 1893 at which Mrs Lawrenson, the president of the women's guild, gave a speech encouraging women to join as it had proved the best training school in habits of thrift and self-control.

As well as its work in encouraging people to join the co-operative movement, the guild became involved in political campaigns specifically relevant to women, including health and suffrage. In response to suggestions that a woman's place was in the home, it was argued that a woman's place was also where she could do good. Among the many issues the guild concerned itself with were health, maternity, housing and poverty. A meeting of the Norwich guild in November 1913 heard Miss Llewellyn Davies speak out on the health problems of young girls who were in work due to poverty, at an age when they should be at school. She argued that their age and working practices were detrimental to women's health, particularly as the ability of these future mothers of England to physically sustain motherhood was seriously affected. The activism and campaigning of the women in local guilds influenced national

legislation, notably when maternity benefits were included in the 1911 Insurance Act.

Nevertheless, the workhouse was still the main recourse for those in poverty. Once they entered the doors, the inmates were classified and divided into separate categories. Men, women and children were normally housed separately in communal dormitories, although some workhouses did have married quarters, usually reserved for long-stay elderly couples. Parents were only allowed limited contact with their children. Basic food was served with different allowances for men, women, pregnant women, children, the sick and elderly. All inmates had to take supervised baths once a week, and wear the workhouse uniform. Unmarried mothers were singled out by having to wear their own distinctive uniform or a large badge.

All workhouses had basic rooms such as a dining-hall for eating and dormitories for sleeping. Each one usually had its own bakery and laundry, plus workshops for various trades and vegetable gardens, orchards and farms. There were also schoolrooms, a nursery, infirmary and a chapel. The able-bodied were given work such as stone breaking or picking oakum (old ropes pulled apart for re-use).

The punishment books for Norwich Workhouse reveal that women such as Priscilla Archer in October 1850, or Maria Cockaday the following January, were confined in a cell for twelve hours or more, lost their meat rations and were put on bread and water rations for being disorderly. Others punished in 1851 included Mary Norton, who was sent to the magistrates' court for stealing a sheet. Whereas Hannah Dickenson's punishment for the same offence in December that year was to be deprived of the treats being given by local philanthropists to the inmates on New Year's Day.

Refusing to work, or not working hard enough, was something else inmates were typically punished for, as Sophia Beesley and Hannah Waller found on 3 September 1862 when they were subjected to seven hours confinement in a cell. Susan Shorten was locked up for twelve hours on 5 September that year for making a 'riotous noise' in the day room and being

violent to the assistant matron. A few days later these three women were confined again for another twelve hours, along with four other women, for refusing to work, making a riotous noise and inciting the other inmates to insubordination.

Such cases of disorderly conduct often included protests over the quality of food. Eleven women, including Francis Dawson, Elizabeth Randall and Charlotte Mason, were put on bread only for dinner rations in February 1863 for repeated insolence towards the nurse. Whereas, when Elizabeth Middleton, Mary Ann Morter and Frances Dennis refused to eat what they were served in August that year, they ended up in court accused of assaulting the governor. Frances Dennis was further charged with attacking a policeman. Those women sent to the magistrates' court for damaging property, assault or theft could expect to be imprisoned. Ann Carver and Ann Woods who were sentenced to a month inside with hard labour

Norwich Workhouse Punishment Book, 1863

in January 1868 were just two of the many women who ended up going from one institution to another.

The Metropolitan Poor Act of 1867 heralded a significant improvement in conditions within workhouses as it required them to set up separate infirmaries. As a result, an increasing number of poor people went into the workhouse because they needed medical care and it was one of the only places in which it was available for free. In 1871, the Poor Laws Board was replaced by the Local Government Board, which had a much greater range of responsibilities such as public health and sanitation.

Large numbers of women who were admitted to workhouses were old or sick. In 1861, a survey was undertaken of every adult pauper who had been resident in a workhouse for five years or more and the reasons why. This revealed that the Norwich Workhouse had seventeen who came under that criteria, of whom six were women, and that all had either a mental or physical disability or illness. The main reasons for admittance remained the same throughout its existence. The admission registers for Norwich Workhouse for instance, list many such elderly women as 81-year-old Sarah Aldis from North Heigham and 82-year-old Harriet Adcock from Lakenham, both of whom entered in in 1893 and died shortly afterwards. A significant percentage had children and were having to go into the workhouse either because they had been widowed or deserted, and could not support their families on their own.

The other largest group of women who ended up in the workhouse were those who had illegitimate children. In 1894 for example, twenty-six women gave birth in Norwich Workhouse, twenty of whom were single. If a woman could not support her illegitimate child, she had no choice but to enter the workhouse as there was no other financial support available. Although it had become more difficult to pursue a father for maintenance after 1834, the workhouse officials could do so, but if a woman was not forthcoming about who the father was then she would be punished. Single women who had illegitimate children were treated particularly harshly. Like abandoned wives they

Norwich Workhouse Admission Register, 1893

were rarely granted out-relief. Many women resorted to theft, begging, the pawnbroker or prostitution in an attempt to make ends meet.

Although out-relief was preferable to going into the workhouse for most women, it was not without its own humiliations. One woman who shared her memories for a Norfolk Federation of Women's Institutes publication *Within Living Memory* in 1972 could recall how, in her childhood in the early 1880s, the poor widows gathered each week to receive their poor relief allowance of £1 6*d*, and a small quantity of flour. Another remembered growing up in Norwich between 1900 and 1910, and the low wages, long hours and fear of

sickness and unemployment, which might mean starvation. She could never forget seeing under-nourished children with ragged clothes and bare feet, and destitute aged people, whose end was the workhouse.

Norwich activist Dorothy Jewson instigated a poverty survey in Norwich in 1912 as part of her election campaign to the Norwich Board of Guardians, which was published the following year as *The Destitute of Norwich and How They Live*. Fifty-nine investigators visited houses across the city in January and February with questionnaires about household income and expenditure. They considered 2,050 people receiving poor relief and found that the majority were families with widowed mothers, or fathers unable to work. In one extract they recorded:

> A woman with four children obtained 10s out-relief and had no other income. Out of this coal cost 1s 6d., and after rent had been paid and oil and wood purchased 6s 0¾d was left for food.

> A family of seven with income, including out-relief of 19s to 20s., expended 1s 5d in a cwt of coal, and had 13s 2½d left for food. The coal was bought in five separate purchases, one of ½-cwt for 8d and four of one stone at 2½d.

Their report included scathing comments on the inadequacy of relief, with cases cited of women being driven in desperation to the streets in order to feed their children. The report asserted that the amount allowed for children of two shillings per week was a starvation wage and that the Norwich Guardians expected nothing short of a miracle by poor widowed mothers to maintain a child.

The relatives of paupers were also expected to contribute to their care costs if they could. The widowed Susannah Baldrey of Heigham had made her living selling fruit and vegetables for many years on Norwich Market with the help of her eldest son. By June 1856, she was 90 and he was 72 years old, and the pair of them were no longer able to continue. Having resorted to

claiming poor relief, the guardians asked her youngest son to contribute. It took several months of legal wrangling where he disputed her inability to continue working – as well as her age – but eventually, after Susannah was taken to London, where her son lived, to give a statement to the court, he was ordered to pay costs.

Susanna's experience was not unusual. In 1899, Mary Ann Lawrence and her husband James were both over the age of 70 and found themselves in need of poor relief. Their son, who was living with his family at Globe Yard, was legally forced to contribute towards their costs as he was still working and received money from his own children.

By the end of the nineteenth century, the conditions inside workhouses were generally much better. Some of this was due to the increasing involvement of women in improving workhouse conditions through bodies such as the Workhouse Visiting Society set up by Louisa Twining in 1858. Her aim was the moral and spiritual improvement of inmates after seeing the appalling conditions in a workhouse when she visited a former servant. Hundreds of members began visiting workhouses across the country and helped implement many positive changes. However, the ladies had no real power as they were volunteers.

The question of whether it was legal for women to be elected to Boards of Guardians meant that very few women were appointed until after 1894, when another electoral reform abolished the property qualification. Hundreds of women took the opportunity to do so. The first women Poor Law Guardians in Norwich were Emma Rump, Kate Mitchell and Alice Searle, all of whom were elected that year. When Kate Mitchell stood for re-election in 1896, her campaign was strongly supported by her fellow councillors such as Councillor Tillett, who felt strongly that there were great advantages in women taking part in public matters at all levels. He argued that women were eminently suitable to be on the Board of Guardians, because there was a workhouse and homes for children with inmates of both sexes. In their efforts, Kate Mitchell and Emma Rump went as far as to personally provide bags for every inmate,

containing a brush and comb, as well as slippers for the infirm, hoists, lifts and bath chairs for the sick, and replace the tin plates with china ones to eat from. The women guardians in Norwich were also instrumental in a thirty-bed girls' home being set up.

Despite some improvements, the stigma surrounding workhouses never went away. Some changes were made to lessen it. For instance, in 1904 the Registrar General advised local registrars that they should no longer record that a child was born in the workhouse on its birth certificate. Instead, the place of birth was to be recorded as a street address. The same practice was later adopted for death certificates.

Little changed for women such as the mother of Ethel George, however. She was the seventeenth child in her family who recalled her memories of growing up in poverty near Barrack Street between 1914 and 1934 in a series of interviews recorded and published by Carole and Michael Blackwell. Ethel's abiding recollection was of how their lives were dominated by the constant struggle to pay the bills and buy enough food to eat. Her mother, like many other women, not only had to contend with appalling poverty and housing conditions, but with domestic violence and a husband who drank away much of his income.

It was a desperate struggle for many. One woman born in 1940 told me how she witnessed her mother giving money to another woman to buy shoes as she could not afford to replace her broken ones and to feed her children, and was therefore walking to work barefoot. Her own mother had taken on running a pub in order to be able to work and provide a home for her children rather than resort to poor relief after her marriage broke down.

A Royal Commission set up in 1905 to investigate the Poor Law and unemployment influenced various pieces of legislation that improved paupers' lives. The most important of which was the introduction on 1 January 1909 of the old age pension for those over the age of 70, although anyone who had received poor relief in the previous year was excluded. In January 1912, the Norwich Workhouse Guardians were able to report that

four women and twenty-one men had left the institution as they could take their old age pensions. Out of the outdoor poor, 149 men and 304 women had come off relief and were taking their pensions. There were still 84 women and 119 men in the workhouse who were eligible for pensions, but were too sick or infirm to look after themselves.

The National Insurance Act of 1911 followed soon after, introducing the first contributory national insurance against illness and unemployment. But, as it only applied to wage earners, large numbers of women were excluded. Nevertheless, those who did qualify for either the pension or unemployment benefits no longer had to rely on poor relief. Included in the Act was some medical treatment for workers, including free treatment for tuberculosis, as well as maternity benefits.

The Poor Law Unions were abolished in 1929, and administration transferred to local authorities. Some workhouses were sold or demolished. However, many were converted into other institutions for the elderly, sick, disabled, unmarried mothers, vagrants and so on, and life for these inmates changed very little. Even with the introduction of the Welfare State and National Health Service in 1948, many of these buildings were used to house the elderly and sick or were turned into hospitals and maternity homes. As a result these institutions were often called the workhouse long after they had ceased to be. Such was the stigma, that even decades later many elderly people refused to enter a hospital that was housed in a former workhouse building. This was the case with the West Norwich Hospital on Bowthorpe Road, which was built on the site of the former workhouse.

The introduction of the Welfare State in 1948 with its 'cradle to grave' health and social care replaced a locally based system that had existed for over 400 years. It introduced a national system based on need, not affordability, paid for via national taxes rather than locally raised rates. The Labour Party politician and Minister for Health, Aneurin Bevan, spoke to those fears when he stated that 'this sounds the death toll for the workhouse'.

For women such as Phyll Clements who grew up in the 1930s and 1940s, and later worked as an NHS midwife at the Norfolk and Norwich Hospital, the new system was 'absolute heaven'. Women no longer had to worry about paying for a midwife or doctor, or their families going without lifesaving medicine, in contrast to the women who lived at Globe Yard in 1914. It was a brave new world for Norwich women.

Housing

Imagine taking a walk in 1850 from the corner of Castle Meadow, turning left into what is now Upper King Street, past the cathedral, then down Tombland and along Magdalen Street. This would take you past the home of the authoress Amelia Opie and the Maid's Head Hotel. On either side were the homes and businesses of auctioneers, solicitors, mayors, sheriffs, shopkeepers and various tradesfolk. Just after the hotel you would walk over Fye Bridge, once the site of the ducking stool used to punish 'scolds' and generally obstreperous women. A diversion left just after the bridge into Colegate would bring you to Sarah Ann Glover's music school at Black Boys Yard. Walking straight on towards the remains of the city gates at the end of the road takes you past the house in the courtyard on the right where social reformers Elizabeth Fry and Harriet Martineau were both born.

If you were to walk this same route in any decade up until the 1930s you would also pass alleyways, yards and side streets with names such as Thoroughfare Yard and White Lion Yard. In them were crammed vast numbers of Norwich residents where several families frequently shared subdivided houses with only one or two rooms each. It was two worlds side by side.

A booming population in the nineteenth century had exacerbated conditions in already poor and crowded areas, and new slums emerged. Most of the women trying to wash clothes and feed their families relied on shared pumps or wells, while open drains ran across the middle. There was little light or ventilation and the toilets were ash closets or privies shared

by several households. So prevalent was the stench and health problems across the city, that as early as 1783, the publisher of the Chase's Norwich directory suggested demolishing the city gates and walls in order to improve the air quality.

A Royal Commission in 1845, into the living conditions in towns and cities, described Norwich as being conspicuous for the dismal neglect and decay in working-class streets and quarters. In the second half of the 1800s and first three decades of the 1900s, the majority of Norwich women lived in poor quality housing in places such as Globe Yard, St Lawrence Yard, Flower in Hand Yard and Coslany Street. There were close to 700 yards in Norwich still in existence in 1900, enclosed within blocks of buildings usually entered through archways from the street. Well into the early twentieth century, they were using communal bakehouses or shared ovens. There was little space for cooking or washing, with women having to carry pails of water from wells or pumps. Washing clothes or bathing entailed the time-consuming task of heating large pots of water over an open fire, or if one was lucky, a range, which were then tipped into a large tub. The river that wends its way around the city was commonly used for bathing and swimming by men, even though it was contaminated by waste and industrial pollution.

A report into living conditions in Norwich in 1851 for the General Board of Health described the innumerable properties with bad water, inadequate sanitation, shared wells and privies, and overcrowded, poor quality buildings. Most of the houses were in yards with no wash houses at all, or having to share one between three or more households. It was common for a family of ten, twelve, or more to be crammed together into one or two rooms, using curtains and screens to try and create some privacy. Fleas, bed bugs, typhus, dysentery, cholera and consumption were rife.

The health hazards were not helped by half of the Norwich's water pumps being next to churchyards. By 1850, the churchyards were overcrowded too, and waste matter was contaminating the water supply. While this particular problem was addressed in 1853, when an act was passed enabling local authorities to

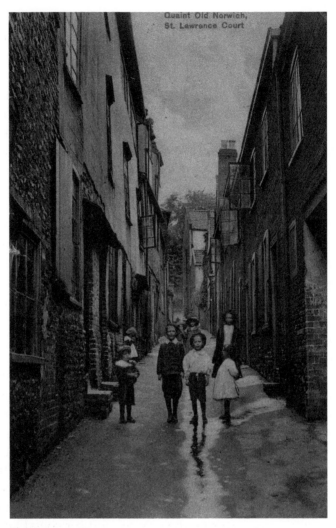

St Lawrence Court

administer their own cemeteries, and the city churchyards were subsequently closed, it did not resolve the wider issues.

Historically, slum clearance and redevelopment evolved out of philanthropic housing movements and other reforms aimed at improving the conditions of the working class. Public health became a huge political issue in the early Victorian period. By the 1840s, social and religious campaigners were pushing

for action against the high levels of infant mortality and poor housing. In towns and cities the prevalence of waterborne diseases such as typhus and cholera were endemic until the discovery of the link between sanitation and public health provided the impetus for developments in public hygiene and indoor plumbing which helped eliminate them. In 1842, a Royal Commission was appointed to investigate the 'Health of Towns and Populous Places'. Two reports were published in 1844 and 1845 that led to the passing of the 1848 Public Health Act. This established the General Board of Health, which could in turn set up local health boards in problem areas.

Planned housing developments were built to provide 'decent' affordable homes for those in 'need' in some way. Such schemes became much more commonplace from the nineteenth century as philanthropic housing developments and slum-clearance programmes began, specifically aimed to provide affordable, decent and integrated communities, usually for the 'labouring' or 'working' classes.

Housing specifically built for workers has existed from at least the eighteenth century, but became much more widespread in the nineteenth. In Norwich, the Colman family built hundreds of homes for the workers at their mustard factory. These mostly 'two up and two down terraces', close to the factory on King Street and Argyle Street and elsewhere, were of good quality, with kitchens, a small garden and privy allocated to each house. Some had a third 'walk through' bedroom leading off one of the others. Many of these houses still exist today, although a large number were taken over by the city council for social housing after the Second World War.

Generally described as 'social housing', the impact of such schemes cannot be underestimated. They raised living standards and expectations and laid the groundwork for the council housing programmes of the twentieth century. Some commentators have gone so far as to argue these were the first buildings specifically designed with the working classes in mind, as opposed to being something the working classes happened to find themselves living in.

In Norwich, the first housing by-laws were passed in 1858. Some of the overcrowding was alleviated by private entrepreneurs as Norwich began expanding beyond its traditional city walls. What had been farmland gradually became the site of the earliest terraced housing specifically built for the working classes in the city.

The Unthank family owned large swathes of land between what is now Unthank Road and Ipswich Road, which was sold to developers who arranged the layout of the streets and sewers such as the Vauxhall Street area, leading out from the old city boundary at Chapelfield Road. Most of the new houses appeared in the 1850s and 1860s. However, these were not aimed at the poorest in the city, but the artisan working classes who could afford to pay a reasonable rent. Deeds to some of those built in the 1860s off Vauxhall Street and Church Street include conditions imposed by the Unthanks on the builder which were fairly typical. Every dwelling house had to be built in the same way, even down to the colour of bricks, type of roofing, windows and the iron gutters at the front and sides. In the case of a property in Marlborough Terrace in 1867 the rent was £9 a year, far above what the poorest families could afford.

In contrast, what was advertised as a 'good brick and tile cottage' at the Heigham Street end of Globe Yard was being rented for £5 a year in 1856. The annual rental value of a group of nine cottages in the same yard when sold thirty-six years later was £60 for all. This was still an average of more than £3 a year lower than the rent paid for similar size houses with gardens and separate privies on Marlborough Terrace when they were first built.

This expansion did not solve the problem of overcrowding for the women who lived in older buildings in places such as Globe Yard. As the century wore on, other acts were passed and responsibility for local housing issues and slum clearance transferred from one body to another. In 1873, Norwich appointed its first Medical Officer of Health. His reports made it clear that epidemics of scarlet fever and typhoid were directly linked to poor housing and crowded and dirty conditions.

Powers to compulsory purchase slums were given to local authorities in 1875. Norwich Council embarked on its first slum-clearance programme soon afterwards. In the parish of St Paul for instance, 144 dwellings in which 505 people lived were demolished and new buildings erected. White's 1883 trade directory for the city noted how the disgraceful tenements had been replaced by 'a colony of trim cottages'.

Nevertheless, there were still thousands of properties such as those in Dial Yard off Barrack Street, whose condition resulted in newspaper reports and complaints over the years. In one tragic drowning case in 1886, the city coroner noted how dangerously open it was to the river as the deceased had fallen in next to Mrs Blyth's house, which was only three or four unprotected steps away from the water.

Dial Yard also featured in a report entitled 'The Slum Explorer' in the *Eastern Daily Press* on 11 November 1897; one local doctor recalled his time as a medical student in the parishes of St James and St Paul thirty years before. Despite the many efforts to improve conditions, the doctor claimed that the soil and the buildings had not improved. He said that while some of the yards had been wholesome with nice gardens, these were very scarce now. Indeed, the typical Norwich yard was a bad thing, with it being almost impossible for people to keep themselves clean. Although he said it was not all nastiness, he singled out George Yard and Dial Yard as typical of those which were bad in all respects:

> In George Yard there are two pumps, from which while I was there, people were taking water. It was very good water, they said; but I had no means of verifying that. I should be inclined to doubt it, for some privy bins were near at hand, and slops and other refuse lay about on the badly paved ground.

The slum explorer's exposé provoked strong indignation from Miss Winter of Cavalry Street, Mrs Brinkley of Black Boy Yard and Mrs Waller of Anchor Street, who were members of a local

missionary society. They suspected his motivations in criticising conditions and believed his proposals for improvement would lead to the aged poor, who were reliant on poor relief, being swept away into workhouses as they would not be able to afford to stay in the single rooms they rented. The women invited the public to visit Dial Yard and Baker's Yard among others to see for themselves how clean they were. However, measures to inspect these places were already underway by the council, and a local reporter followed up by making his own visit just a week before the women's invitation and wrote how,

> Baker's Yard has a stinking drain near the cobble-paved entrance passage, not four feet from the road. The houses are clean and respectable-looking outwardly. The ancient pump is very decrepit, and the surplus water from it, as well as from the two yards which together form Baker's Yard, all flows to the drain near the street. The four privies attached to the first yard adjoin the houses at one end, only being separated from one of the cottage doors by a wooden screen. The further yard is neat and cleanly [sic]. No lighting.

> Dial Yard is approached through a very narrow entrance passage, and has a labyrinth of passages and openings leading from it. On the wall of the house opposite the pump from which the water supply is derived there were marks of an accumulation of filth 2 feet high. At the time of the visit there was refuse and dirty water standing round the drain, in at least half-a-dozen places. In some places the water has to run uphill to the drain, a by no means unusual phenomenon. A drain near the entrance was also full of decaying vegetable matter. Another approach to this yard is unpaved. In the middle of the passage was a drain blocked with refuse, very close to a bake-office. No lighting.

Two years later, Dial Yard was among those private roads ordered by the corporation to be paved, a sewer laid, channelled

and levelled and proper lighting provided, as part of the city wide improvement schemes.

On 27 January 1885, seven cottages in Globe Yard were sold at auction. Four of them had a long garden each at the front, with a separate washhouse and privy, and their total rent amounted to £29 18s. Another three similar cottages adjoining them were also being sold, which had five occupants including a Mrs Chapman, who paid a total rental of £33 3s each year.

Despite this rather glowing advertisement, there were complaints to the sanitary committee of Norwich council in 1887 about the disgraceful state of the bin in Globe Yard. At this time, fewer than 5,000 residents in Norwich had water closet toilets, and this type of bin was used for storing human waste from the privies or pail closet toilets that were the most common conveniences in the city's yards. Although they were emptied at regular intervals and were cleaner than privy pits, they often overflowed. One resident who lived close to the corner on Heigham Street resorted to writing to the press about the contaminated water causing a frightful stench and running into the yard and down the drain only yards from the well.

More regulation occurred. From 1877, plans for new houses had to be submitted to the council, and from 1889 minimum requirements regarding room height and open space at the rear of new buildings came into force. This did not, however, resolve the problem of overcrowding in the old houses in the yards, courts and alleyways. By the late nineteenth century, it was clear that this piecemeal system could no longer cope. The 1888 Local Government Act became the first systematic attempt to impose a standardised system of local government in England. This created county councils, all run by elected councillors, who were responsible for general local government business plus the management of roads, bridges and drains.

The following year, Norwich City Council passed the Norwich Corporation Act, which regulated every aspect of public administration, including sewerage, drainage and control of infectious diseases. The Local Government Act of

1894 finally completely separated the administration of the community from that of the church at parish level, by creating parish councils which took over the Church of England's civil responsibilities. These civic parish councils took care of allotments, burial grounds, drainage, lighting, planning, recreation, street furniture and village halls. Further acts changed the specific functions of local government, but it still remained separate from the church and court systems.

Further powers to deal with housing schemes and unsanitary dwellings came with the 1890 Housing of the Working Classes Act and the 1909 Town Planning Act. The former gave local councils further powers to deal with unsanitary dwellings, leading to large-scale slum clearances and the provision of some municipal housing. The latter also introduced the compulsory appointment of a Medical Officer of Health.

Although Norwich's population fell behind the expanding industrial centres elsewhere, it still had over 100,000 people living in it by 1900. In the first part of the eighteenth century the city was dirty, overcrowded and unsanitary. Under pressure from the growing population and expanding industries, hamlets, which had been separate rural parishes, became subsumed by the spread of building. Houses for the middle classes were built in places like Thorpe Road in Thorpe Hamlet. This area was developed partially because it was close to the new railway station, enabling easy access to transport.

The position of the working classes gradually began to improve despite poverty, disease and uncertain employment. As a result, most could expect to live in a house with around four rooms by the time Queen Victoria died in 1901, rather than be crammed into one room as many had been in 1851. Nevertheless, at the turn of the twentieth century there were still thousands of properties across the city reliant on wells and pumps, sharing washing and toilet facilities in substandard housing.

In 1902, Norwich City Council took measures to improve many of the streets and yards in the city. According to a report in the Norfolk Chronicle of 24 May, they were to be 'sewered, levelled, paved, metalled, flagged, kerbed, channeled' and

made good, and proper means for lighting be provided by the Corporation'.

However, organisations such as the Co-operative Society were active in pointing out how detrimental poor housing was to workers' health as well as to their morals. At a conference held in Norwich in April 1902, speakers argued that the home was the 'natural soil of national virtue'. Moreover, a good home was the starting point of all social reform. They suggested that the proper way to relieve overcrowding was to provide accommodation elsewhere before clearing the districts affected.

The terrible conditions endured by some of the women of Globe Yard, as well as their families, friends and neighbours, were drawn attention to in January 1907, when Rebecca Armes was called to give testimony at a coroner's inquest into the death of her neighbour Edmund Burrell from pneumonia and heart failure. Local newspapers such as the *Diss Express* headlined his tragic death as 'How the Poor Live – and Die' when they reported the case.

Rebecca described how Edmund had lodged and worked in the upstairs room of a neighbouring house for around ten years, which he also shared with his adopted son. The coroner referred to the filthy state of the room, which was, he said, 'a hell for people to live in', as it was not safe to go upstairs or down, and was the worst case he had ever seen. The jury had seen these horrible conditions, and several severely criticised the state of affairs, with one wondering why the sanitary officials had not taken the case in hand. The coroner did, however, commend Rebecca and her daughter for their efforts in trying to help Edmund.

When the 1911 census was taken there were fifty-three females living in the nineteen occupied households listed at Globe Yard. The majority had four rooms, including a kitchen, but some had only two or three, although any scullery or toilet were not counted by the enumerators. Emma Burrell at number 1, a single woman aged 53 and working as a sewing machinist, had two rooms. The widowed Beatrice Smith, aged 27 and her 2-year-old son at number 8 also had two rooms. Others

were much more crowded, such as Eveline Goodbody and her husband James who shared four rooms with five children aged between 8 and 18, while Mary Howard shared her home with nine children. The most extreme example of overcrowding in the yard was number 17, where 35-year-old Amelia Earley, her husband William and eleven children aged between 9 months and 16 years were crammed into four rooms.

Taking in lodgers to add to the household income was a necessity for many. The Betts family of four shared four rooms at number 2 Globe Yard with a boarder; the widowed 68-year-old Hannah Cadway, while William and Florence Brown at number 9 had an 18-year-old boarder, Charlotte Smith, who worked in the boot trade.

At number 4 Globe Yard, Frederick and Rebecca Armes, aged 66 and 56 respectively, shared their four rooms with three children and a grandchild, aged from 15 to 24. It was a slight improvement on when the census had been taken ten years earlier in 1901, when there were ten people squeezed into the same property.

When Dorothy Jewson and her brother organised a survey into poverty in Norwich in 1912, it revealed that out of the 895 families interviewed who were receiving poor relief, 54 shared a water closet with four or more families, while 58 lived in places where a single water tap catered for 7 or more families.

After the First World War, responsibility for housing was transferred to the Ministry of Health. The inter-war years saw a number of initiatives in towns and cities to tackle poor housing stock, and the related problem of poor public health. Schemes such as 'Homes Fit for Heroes', which promised homes and jobs in reward for the sacrifices made during the First World War, were the first attempts at a national programme of local authority housing. Large numbers of houses were built, mostly in the suburbs and areas in which new industries were based. Large-scale building companies emerged, aided by government subsidies and cheap land costs. In Norwich, new streets were laid out close to shoe factories and other major employers.

Much existing housing was improved at the same time. Places such as Dial Square on the corner of Mile Cross and Heigham Street, another area of deprivation, completely disappeared when a new road was built in the 1920s, while other areas were redeveloped.

Norwich city council embarked on a programme of council house building. Five estates were proposed at Mile Cross, Drayton Road, Earlham Road and Angel Road. The first ones completed were at Mile Cross in 1926 at rents from five shillings a week depending on size. The council built over 7,500 houses in the 1920s and 1930s and rehoused around 30,000 people, almost a quarter of the population. Community facilities were created around them providing schools, shops and a church. The early tenants were vetted for their ability to pay, and the occupants included shoe factory workers, clerks and teachers, while priority was given to ex-servicemen.

One woman who recorded her memories for the Norfolk WI in 1981 recalled the excitement of being relocated from Angel Yard to one of the new council houses in 1920. Once day the postman brought a letter and her father 'turned to my mother and said: "Well, we have one at last". Then everyone started talking all at once, and there was lots of laughing. Mother went next door to let them know we "had one".' It took two or three trips with a hand cart to move all their belongings. Her father and mother were all smiles as they pushed the last cartload and pram with the youngest children in it. She wrote how:

> It seemed huge compared to the one we had just left. It had five large windows and a door at the front, and more windows and a door at the back. As I walked through the front door I saw in front of me a huge stairway with beautiful red shining lino, which was held in place with steel rods shining like silver. Oh! We were rich!

> I found the lavatory. It was such a dear little room with a huge white basin that had brown wooden seat that lifted up. Over the top of the funny basin was the tank. A chain with a handle hanging down got my little brain

working. I discovered that if the chain was pulled down, lots of water swished around the inside of the huge white basin, then disappeared out of sight. I spent many a time just pulling the chain.

I participated in an oral history project in the early 1980s recording women's experiences. Their memories and those of other Norwich women interviewed over the years presented an overwhelming feeling of gratitude for their spacious, comfortable new council homes. Houses such as those on Rye Avenue had three, four or five bedrooms, a coal-fired range heating the house and hot water, a kitchen and a bathroom. Others followed soon afterwards, and the council also gradually took over some of the housing provided by other organisations in the city.

By 1932, the Mile Cross Estate had around 1,400 council homes. Other estates soon followed. At the same time the council embarked on a further round of slum-clearance schemes in the city centre. It was the turn of Globe Yard and others like it in 1937. They were not missed. One of the women

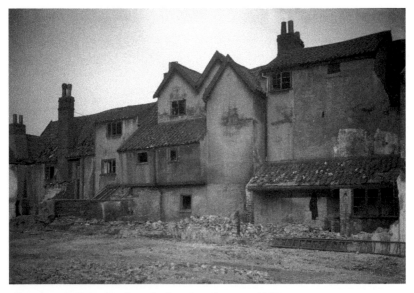

The rear of Globe Yard just before demolition in 1937

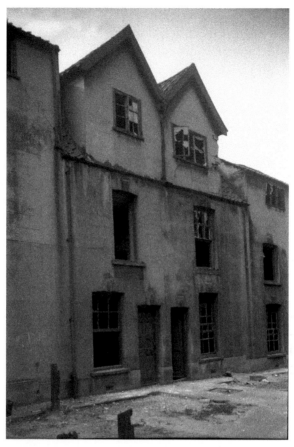

The west side of Globe Yard just before demolition in 1937

contributors to 'Within Living Memory' recalled the poverty and overcrowded tenements of places such as Paradise Court, Flower in Hand Yard and Rising Sun Place, which she knew between 1900 and 1910. Now, she said: 'those sad things are gone, and are only memories'.

These clearances of the 1930s, followed by the destruction caused by bombing attacks during the Second World War, enabled a new vision of how urban areas could be reconstructed. There were forty-five bombing raids on Norwich during the war, resulting in 340 deaths and over a thousand injured. 14,000 houses were damaged, of which 1,200 were destroyed. A 7sq ft

bomb map held at Norfolk Record Office denotes where and when bombs fell. This, and other city engineer's records, detail the extensive damage that occurred during the war, particularly the Blitz in 1942. The list of streets damaged on the nights of 27 to 30 April 1942, included Heigham Grove, Barn Road, Nelson Street and Westwick Street. 14-year-old Daphne Clapham, 17-year-old Barbara Clapham, 81-year-old Anne Page and 51-year-old Clara May Turner of Globe Row, close to where Globe Yard had stood until a few years before, were just a small fraction of those killed on the night of 28 April 1942.

The 'City of Norwich Plan' of 1945 set out the council's plans to regenerate the city, with a focus on housing. The Town and Country Planning Act of 1947 was introduced to deal with the effects of bomb damage, slum housing and town planning and to regulate the building of new homes. It was part of the project to build a better Britain linked with the new Welfare State which would provide healthcare and housing from 'cradle to grave' regardless of ability to pay. The period after the Second World War saw one of the biggest ever housing programmes. After the war, a widespread repair and rebuilding programme began with many of the old, badly damaged, terraces being demolished and replaced by modern houses and flats. Older properties were repaired and renovated.

By 1950, the vast majority of the old slums in Norwich had gone, with over 6,500 new council homes being built by 1955, while new private sector housing also began to appear in the city as the rationing of building materials was lifted. The majority of women who had grown up in areas like Globe Yard now had comfortable, safe and affordable homes.

Norwich Women and The Vote

In 1918 the world changed for some women over the age of 30 in the UK as those who were ratepayers, or married to ratepayers, were finally given the right to vote for a member of parliament. However, none of the women who lived at Globe Yard off Heigham Street were among those able to vote in the parliamentary elections held the following year, and neither were thousands of other women in the city.

While it would be another ten years before every woman could vote on the same basis as men, it was a watershed moment as it marked the culmination of a series of campaigns and fights to improve women's position within society. It also represented an enormous cultural shift over whether women were capable of making such an important decision.

Yet the fight for the right to vote in parliamentary elections often overshadows how women helped transform society, and played a part in local government in the preceding fifty years. Their actions through participation on school boards, as workhouse guardians of the poor, as local councillors, and through voluntary and charitable work paved the way.

Two of the most notable Norwich women in the second-half of the nineteenth century were Amelia Opie and Harriet Martineau. Amelia Opie, née Alderson, (1769–1853) was a celebrated author and anti-slavery campaigner. She was born into a Nonconformist family who attended the Octagon Chapel on Colegate. By her early twenties she had published a novel,

Statue of Amelia Opie

contributed several poems to anthologies, and was writing and performing her own plays as well as writing songs. After the death of her husband she returned from London to Norwich and made her home on Castle Meadow.

Amelia's political interests were stimulated by the French Revolution and her father's involvement in the Norwich reform movement. She devoted her life to improving conditions in workhouses, hospitals and prisons and for the poor. She became a Quaker at the age of 56, and supported a refuge for reformed prostitutes and the Norwich branch of the Bible Society. Her greatest cause was her work on behalf of the Anti-Slavery Society, and in 1840 she represented Norwich at a national anti-slavery convention. When Amelia died in 1853, she was buried with her father in the Quaker burial ground on Gildengate. Sadly, when a plaque was erected close to her home, it gave as much attention to her husband and father as it did to her, and failed to mention her political activism.

A little courtyard off Magdalen Street saw the birth of Harriet Martineau in 1802. She would go on to become an author, social reformer, economist and one of the first female journalists, as well as being celebrated around the world as a pioneer of modern sociological ideas. She was brought up as a Nonconformist and worshipped at the Octagon Chapel on Colegate. Harriett had a good education as her parents believed that girls should be educated as well as boys, although she had to contend with going deaf when she was a teenager. Harriet chose not to marry as it would constrict her independence and she made her living as a writer. She had a prolific output, although her first articles were published under a male name. Although her early years were cushioned financially because her father was a wealthy bombazine manufacturer, she lost money through bad investments when she was in her twenties so that earning a living became a necessity. Later in life Harriet claimed to have cured herself of a serious illness through mesmerism (self-hypnosis).

Harriet Martineau spent her life campaigning for legal reforms that would benefit women, advocated being able to divorce and the use of birth control. The campaign most associated with her name was the abolition of slavery, which she devoted herself to, and travelled across the country to speak out against, despite threats of violence against her. In 1866, she was one of the signatories on the first national petition presented to parliament demanding female suffrage. Harriet was still campaigning until shortly before her death in 1876, having signed the female suffrage bill presented to parliament only three years before. Yet Harriet's importance has often been overlooked, not least in the city of her birth where Martineau Lane is actually named after her uncle and not her.

The road to female suffrage – having a legal say in who represents the electorate in parliament – has long roots. Calls for women to be included have been made as far back as the 1640s, but never on the same scale as the demands for male suffrage to be widened. Until 1918, the right to vote for a member of parliament was restricted to men and based on a

property qualification, which meant that only those who paid rates above a certain level could do so. This also limited how many men could vote. Out of total population of just over two and a half million men in Britain, fewer than five thousand were entitled to vote for a member of parliament in 1831.

Even at a parish level, it was ratepayers who took on the roles of churchwardens, overseers of the poor, surveyors of the highway. While these roles were almost always confined to men, the occasional financially independent widow or single woman did manage to be accepted, although that does not appear to be case in any of the thirty-odd parishes in Norwich.

Although the electoral franchise was gradually expanded to include more men over the next seventy or so years, it took until the latter half of the century before women were granted some rights. The nineteenth-century suffrage movements grew out of pressure for reform by groups such as the Chartists in the 1830s and 1840s. The modern women's suffrage movement began with the formation of the Sheffield Association for Female Suffrage in 1851. Other groups followed, but success in getting a bill passed depended on the support of male MPs in the House of Commons. The recognised method to gain that support was by presenting a petition. The first mass petition with over 1,500 signatures calling for women to have the right to vote was presented to parliament in 1866. Although this was defeated, it marked the beginning of an era of increasing activism in support of female suffrage, plus the opening up of opportunities for women to be involved in local politics.

The widening of the franchise in 1867 meant that one-third of the adult male population could vote in parliamentary elections, and spurred on those fighting for women to be included. The MP, John Stuart Mill, unsuccessfully proposed changing 'man' to 'person' in the Act so that it covered women, but the response was that 'men' did not include women and only men could vote. However, one woman in Manchester, who was accidentally included as only the initials of her first name were given, did manage to vote in a by-election in that year, although

her vote was subsequently revoked once it was discovered she was a woman.

In 1869, a last-minute amendment to the Municipal Franchise Act enabled women rate payers to elect local councillors. Unfortunately, this was taken away from married women three years later as a result of a court case when a candidate in Sunderland lost by one vote. He went to court to argue that as two of the voters were married women they were not entitled to vote. The court agreed that the Act permitting women to do so could not override the principle of coverture, where women's rights were subsumed into those of their husband's once married. In Norwich there were 2,600 female voters to 14,000 men.

Despite being excluded from having a say in electing representatives to government, a small number of women were having a say in local elections for parishes, boroughs and county councils, as well for who could serve on school and Poor Law boards. Nevertheless, from 1870, women could also be elected to public office for the first time when they were allowed to be elected to school boards. As already seen, many women in Norwich embraced this chance, and it is no coincidence that many supported female suffrage. They included the author and school's inspector Margaret Pillow, whose wedding reception was held at the residence of Mr and Mrs Pankhurst in London.

Those women who began to be listed on electoral registers were overwhelmingly middle and upper class. They included women who ran their own businesses as well as those who were property owners. Lucy Brewer was born in 1822 and was one of the women who benefited from the extension of suffrage in 1867 to a wider group of ratepayers, which also enabled widows and single women to vote in local elections. She first appeared on local electoral registers in 1872, when she was one of nine women out of thirty entries on that page for the Town Close Ward. Her qualification to vote was paying rates on a house on Town Close Road where she made her living running up a small boarding school for boys. She never had the opportunity to vote in a parliamentary election as

she died in 1890, but by then even more changes had occurred to benefit women.

The married women's property acts of the 1870s and 1882 reinforced the arguments for greater democratic representation. Although there had not been one name with a Norwich address among the signatories of the 1866 petition, some women connected to the city, such as Harriet Martineau, did sign. There were also an increasing number of meetings and lectures in Norfolk from 1869 onwards in support of female suffrage, but this did not necessarily equate to giving the vote to all women. A significant number only argued for women being able to vote on the same basis as men, which meant retaining the property qualification, which by its nature still excluded the majority of women.

Norwich's own female suffrage petition was presented on 3 June 1869, but contained only thirteen names. Another was presented three years later, and the first public suffrage meeting in the city occurred in April 1873. Other meetings and lectures occurred over the next few years, but it was not until 1878 when a suffrage tour next stopped in the city. This appears to have inspired the setting up of a Norfolk committee. In January 1880, an enthusiastic audience was reported as attending a lecture held at St Augustine's Boys' School Room on the topic of 'Woman's Duties Towards the State', which heard Miss Helena Downing argue that:

> The question of women's suffrage was a large one. They had practically to consider the case of more than 2,000,0000 women who were unprovided for by marriage. So numerous a class must needs have grievances of its own, and it was only fair that it should have some voice in removing them.

Miss Downing went on to state that the law over married women's property must be amended first, and that issues relating to the custody of children and labour hours were of deep concern. In March the same year, Lydia Becker addressed

another audience of over 3,000 at St Andrew's Hall in support of female suffrage. It would, however, be another eight years before more major suffrage meetings were held in the city, although there was undoubtedly much debate and campaigning going on in other organisations, and several branches of the NUWSS existed elsewhere in Norfolk.

Sisters Emily and Lucy Copeman were those among the Norwich women taking a keen interest in local political affairs, as revealed by their letters in the 1870s and 80s to their brother, Henry John Copeman. Their father had co-founded the *Norfolk News* newspaper, and their brother was a city councillor who later became a sheriff and mayor of Norwich for the Liberal Party. However, their views on what was appropriate behaviour and positions for women reflect common attitudes. On 26 March 1881, Emily wrote to Henry saying:

> I had a little information on your last paper on Women's Suffrage. I should like to see the latter very much. I hope you pleaded our cause fairly. I do not think women ought to be debarred from certain studies because they are women, their capabilities in my humble opinion, ought to be the test on that score, but I do hate strong minded, masculine, mannish women poking themselves forward into prominent positions belonging only to men.

The 1882 Married Women's Property Act finally enabled women to have full rights over their own property, and to be able to make a will without their husbands' consent. The next major step in women playing an active role in public life and politics occurred under the 1894 Local Government Act. Firstly, local voting rights were regained, which once again allowed married women to vote if they fulfilled the property qualification. Second, it was now possible for all women ratepayers to vote in, and be elected to, parish and district councils. Third, the confusion over whether women could be elected as guardians of the poor for the workhouses was resolved. Although the first woman to have been elected in England was in 1875, there

were disputes over whether it was legal as only ratepayers could stand, which precluded most women. The rule change in 1894 removed the property qualification and more women began to come forward. Emma Rump, Kate Mitchell and Alice Searle were elected as the first female Poor Law Guardians for Norwich in that year as Liberals.

Other groups began to appear alongside those specifically working for women's suffrage who also played a major part in improving the position of women in society. One of the most influential was the Co-operative Women's Guild. As already mentioned, it was set up in 1883 to provide women a voice within the movement as it was usually their menfolk that attended meetings. Attempts to start local branches often provoked the response from men that women should stay at home, while the women themselves felt that they could not be spared from domestic duties. When a branch secretary in Norwich in the 1880s asked women to come out for an hour or two to enjoy themselves, they nearly all replied that they never went out, but their daughter or husband and children would. However, the focus of the guild as a means of enhancing womanliness and creating better wives and mothers went a great distance towards encouraging support from men, and more women joined.

When the first annual outing of Norwich Society of Co-operators took place in 1893, Mrs Lawrenson of London, the president of the Co-operative Women's Guild, addressed the meeting at some length. Her theme was that cooperation was a bond that united men and women, old and young. She was able to boast that it had special advantages for women by pointing out that they had been invited to take a share in the management of societies and to hold office from the very first. Not only that, but even before the Married Women's Property Act, the pioneers of the movement had protected the property of their female members, and often refused to give their bonuses to their husbands. She went on to say that:

The chief work of the Women's Guild was to educate people on the question of co-operation. Co-operation

had proved the best training school in habits of thrift,
self-control, and toleration. Co-operation meant men
and women working together in all the details of life,
and recognising that as human beings all are equal.

One of the key members of the Norwich branch was Esther
Florence Gee (née Frost), whose husband was secretary and
manager of the Norwich Co-operative Society. She was a
brickmaker's daughter born in Shottesham in 1849. By 1871 she
was working as a mantle maker and lodging at Raglan Street
off Dereham Road. She married Joseph Thomas Gee in 1875.
Although Esther never held a paid post, she played an integral
role in developing the guild and promoting causes beneficial
to women.

Esther Gee held the presidency of the Norwich Women's
Guild for many years and was an active member of the National
Council for Women. Her name appears over and over again
on the minutes and reports of meetings, although she was very
rarely referred to by her first name. Among the causes the guild
championed were improving work conditions and expanding
educational opportunities for females, and alleviating poverty
and improving housing conditions in the city. When Mrs Gee
died in 1934, she was celebrated for having furthered the cause
of cooperation in Norwich.

In 1897, the National Union of Women's Suffrage Societies
(NUWSS) came into being when seventeen regional women's
suffrage societies grouped together. It was led by Millicent
Fawcett and believed in peaceful campaigning, and its members
were known as suffragists, along with their moderate male
supporters. Six years later, in 1903, the Women's Social and
Political Union (WSPU) was formed by the Pankhursts. The
WSPU believed in direct action, and it was in response to tactics
that the *Daily Mail* coined the term 'suffragettes'.

By 1900, ratepaying women formed 14 per cent of the local
government electorate, with more than a million listed on
electoral registers in every section except parliamentary voters,
but there was still a great deal of resistance to expanding this

to include the parliamentary vote on any terms. Arguments against ranged from women already being sufficiently represented by men; being too easily influenced; that it could create family discord if a wife and husband disagreed over who to vote for; it could cause women to withdraw from their proper sphere of domestic duties; that men would no longer be courteous to women, and that the excitement caused by political strife could lessen a woman's physical powers, and even lead to insanity.

Despite the growing numbers of middle- and upper-class women being able to vote in local elections and to be elected to school and Poor Law boards by this time, these changes had little impact on the lives of the majority of working-class women in Norwich or elsewhere. The women of Globe Yard are representative of the picture across the city. The electoral registers for 1901, for example, show that there were fourteen men living or owning property in Globe Yard who were registered to vote, but no women. Three of the men fulfilled the property qualification on houses elsewhere, but the other eleven paid rates on the properties they lived in. The only woman connected to Globe Yard listed at any time before the First World War was Florence Newton, who appeared on the 1914 and 1915 as paying rates on number 8, as well as having a house on Timberhill.

From 1907, women were able to sit on city, borough and county councils. In Norwich, one woman was elected in 1913. By 1920, there were three, and thirty years later there were eight. It took until the 1980s for women to form over 35 per cent of the city council representatives. Annie Elizabeth Reeves (née Wilkinson) was the first woman to stand as a councillor in Norwich in 1908 and 1909, although she was unsuccessful. She was also an exception in being from a working-class background. When she stood as a Socialist and Labour candidate in Wensum Ward in 1909, Annie came second place with 273 votes. She was, however, successful in her attempt to be elected as a Poor Law Guardian that year, and became the first Socialist and Labour Party woman to be elected to a political office.

Annie Reeves was born in Sleaford in Lincolnshire in around 1866, but had moved to Norwich by 1891, where she lived at the Bungalow, St Stephen's Street, with her husband, son and brother-in-law. She was unconventional and had already been politically active for many years. In 1904 and 1905, she was summoned to the magistrates' court along with her brother-in-law, and fined for refusing to pay the portion of the poor rates devoted to educational purposes on conscientious grounds – she was against it being put towards church schools and religious education. Some of her goods were seized and sold at auction after she refused to pay the fine. In a letter published in the *London Daily News* on 14 June 1905, she wrote to comment on a similar case in the capital. In it, she complained how an eight-day office clock and two silver watches worth nearly £7 had been sold, but as the sale took place without a public notice they were knocked down for a few shillings, and there was a deficit. As a result, she was to be disenfranchised from voting in local elections unless it was paid. She finished by saying: 'it would certainly not be', and 'I will not sell my liberty for a vote'.

Annie was also very involved with the Women's Labour League and the Norwich branch of the suffragettes. When the 1911 census was taken, thousands of women refused to be recorded on the basis that if women did not count when it came to the vote, neither would they be counted. Many forms were spoiled or not filled in, while many women avoided being at home on the night the census was taken. Annie Reeves was among those who stayed away from home. Her brother-in-law filled in the household form for himself and her son and wrote: 'In accordance with an agreement with the Women's Social and Political Union, I refuse to give any particulars of females living in the house.' The enumerator added a note to say that there were no females living there, even though there was no doubt that Annie did live there with her name being listed on several years' worth of electoral registers before and after 1911.

Annie spoke at several suffragette meetings. At one held on Norwich Market Place in July 1912 she declaimed: 'We are tired of men thinking us angels. We want them to think us women.'

When hundreds of Norwich people were made homeless during the great flood which occurred in the winter of that year, Annie referred to the disaster as a godsend as it revealed the terrible conditions in which many Norwich residents lived. She followed this by calling on the council to replace the lost homes, and insisted that all council houses should be built to the highest standards regardless of people's income. Annie remained actively involved in politics locally until at least 1915. Among the many causes she lent her support to were the Burston School Strike and Irish Independence. After she moved to London she became the consort mayoress in St Pancras in 1919, and unsuccessfully stood for election to parliament the following year. She spent time living in a commune on the north Norfolk coast in the 1920s, and died in 1934. Her activism and radicalism helped pave the way for many other women to take public office in Norwich.

At the turn of the century, women campaigners for suffrage were becoming divided as to the most effective methods for achieving the vote. Some believed it should only be done via lobbying parliament and peaceful means. Others, such as Annie Reeves, became more militant as time went on and threw

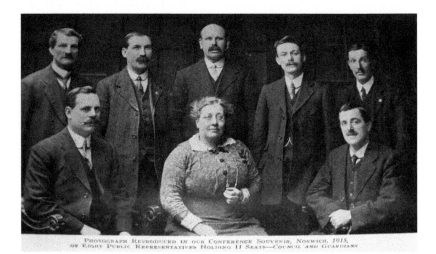

Annie Reeves: One of the eight representatives at the Independent Labour Party Conference, 1915

themselves behind the Pankhursts' direct action campaign and adopted the slogan 'Deeds not Words'. In February 1907, around 800 women marched on the Houses of Parliament, which ended in violent confrontation with the police.

The WSPU itself split the same year, with Emmeline Pankhurst forming the national WSPU who pledged not to support any elections unless women were granted the vote. Those members who wanted to work with the Labour Party had to leave, and formed the Women's Freedom League, which by its nature attracted working-class women far more than the WSPU did. A Norwich branch of the Freedom League was set up by Margaret Jewson in 1909. Other groups with Norwich branches supporting female suffrage also appeared, such as the Church League for Women's Suffrage and the Men's Political Union for Women's Enfranchisement.

Women from Norwich had joined the largest suffragette meeting and demonstration held on 21 June 1908, when between quarter and half-a-million women congregated in Hyde Park. Local campaigns by both suffragists and suffragettes were also stepped up. Those coordinated by the WSPU in Norfolk were originally conducted from its Ipswich centre, but by 1912 Margaret West was based at 32 Bracondale, Norwich, as a WSPU organiser, and an office was opened at 52 London Street. In January that year, local suffragettes managed to gain entrance to a meeting at St Andrew's Hall being addressed Herbert Asquith. Sixteen of the heckling women were evicted and then tried to hold their own meeting at the Haymarket, but were driven off by a crowd hurling fish offal and mud and singing over their speeches.

Although there was conflict between the militant and non-militant branches of the suffrage movement, there was a great deal of sympathy for the activists among Norwich suffragists. When the local branch of the National Women's Suffrage Societies (NUWSS) was established in February 1909, the press described the women as having carried on propaganda for some weeks 'in an attempt to extort an extension of the franchise from unwilling men'. There was a good attendance at the

The suffragette office building at number 52 London Street

foundation meeting, with the chair taken by Miss Grace Sewell, with Miss J.M. Caley as organising secretary, and Mrs Green and Miss C.M. Nichols in support. This was almost certainly the artist, Catherine Maud Nichols. Miss Sewell declared that: 'women's suffrage should not be treated as a party question, but as a measure of simple justice'. Furthermore, women householders had to pay taxes, and were not represented. Women at the meeting then went on to express their support for

the suffragettes, even if they did not necessarily feel that they themselves could take such actions. Mrs Green, for instance, made the point that:

> Women of intelligence and education had felt it very hard that they should not possess the right exercised by their gardeners and grooms and even by the street cleaner. Some people might not approve of the methods that had been adopted by some of the advocates of women's suffrage, but whatever else might be said upon that subject, it was undoubted that the courage and intrepidity the agitators had displayed had done more to arouse interest in this subject than anything else.

After speeches in which various women pointed out the injustice of denying women the vote, and what women could offer by being allowed more of a say in political matters, Miss Caley addressed the meeting and made the point that:

> She represented the non-militant party. The society she represented had been formed fifty years, with Mrs Fawcett as president. They had worked quietly, and always constitutionally, and had done much good. They had undoubtedly been greatly helped by the militant party – (Hear, hear) – to whom all honour was due for the attention they had attracted to the movement. She wished she had the pluck to be with them – but she hadn't.

In another meeting held on 6 December 1909 by the Norwich Women's Suffrage Society at the Assembly Room of the Agricultural Hall, the chair was taken by Laura Stuart, and the leading speakers were Lady Frances Balfour and Mr Walter McLaren. When Lady Balfour took her turn she said that she would welcome any question or interruption made in a coherent manner. Her next comment caused a great deal of laughter as: 'She admitted that the last occasion upon which she made that invitation her meeting was immediately broken up by noises

which could not be answered, and which were not coherent, and she felt a little nervous in asking for interruption of that kind.'

In the years preceding the First World War, the goal of female suffrage on some level inched ever closer. The NUWSS set up a shop at number 7 Brigg Street in January 1910. The front was decorated with a large flag on one side with the large lettering 'Women's Suffrage', and a poster saying 'Voters petition' on the other, which were designed to draw male voters in to sign a petition in support. A bill which would have granted suffrage to the one million women who owned property with a rateable value of over £10 a year was passed by the Commons soon afterwards, but failed to become law. Another bill was introduced the following year but defeated by just fourteen votes.

These setbacks exacerbated some of the divisions within the movement over what form suffrage should take. Many of the campaigners were only arguing for suffrage on the same terms as men, which meant that the property qualification would still remain. Others in Norwich such as Margaret West, Dorothy Jewson and Miriam Pratt wanted the extension of the franchise to all men and women on equal terms. On top of which there were still major disagreements over whether peaceful or violent protest were the best means to achieve their goals.

The year 1912 saw an increase in direct action campaigns in Norfolk. It was suspected that suffragettes were behind an arson attack on empty mansion near Newmarket Road in April, although no one publicly claimed credit for it. In another incident the words 'Votes for Women' were written across the front of Bunting's drapery store on Rampant Horse Street, when their plate glass windows were smashed in May. Violet Aitken, the daughter of a canon at Norwich Cathedral was among the Norwich women arrested elsewhere for a similar protest in Regent Street, London.

One of the largest suffragette meetings to be held in Norwich took place at St Andrew's Hall on 11 December 1912. Emmeline Pankhurst was invited to speak. The hall was packed, but a large number of young men chanted and shouted throughout Emmeline's speech, making it impossible for anyone to hear.

Ironically, their tactics backfired as the outrage generated by their behaviour converted a great number of Norwich people into supporters.

In 1913, the Norwich branch of the Electrical Trades Union threw its official support behind franchise reform and the

Letter from the Norwich Women's Suffrage Society to the Electrical Trades Union thanking them for supporting female suffrage, 26 November 1913

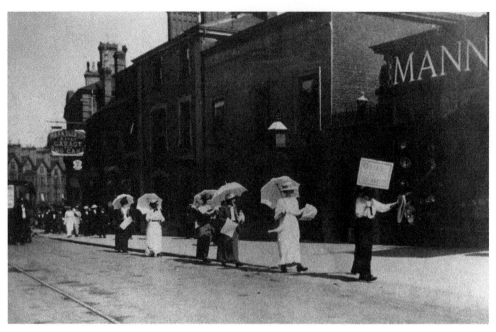

Suffragettes on Prince of Wales Road circa 1914

suffragists. The honorary secretary of the local NUWSS, Edith L. Willis, wrote to them in return, expressing her pleasure that the resolution had been passed unanimously.

Another local woman, Miriam Pratt (1890–1975), was among those who felt driven to violent tactics. Although they came from very different social backgrounds, she became a close friend of Dorothy Jewson. Miriam was born in Windlesham in Surrey on 26 January 1890 as Annie Miriam Pratt. She moved to Norwich to live with her maternal aunt, Harriet, and Harriet's husband, William Ward, in around 1898. Her sister, Harriett Emma Pratt, had also moved to Norwich by 1905 to live with another maternal aunt, while her brother Charles relocated there sometime later after serving in the navy.

Miriam went through the pupil-teacher training scheme while continuing to live with her aunt and uncle. By 1911 they were living at number 7 Turner Road in Lakenham, and Miriam was working as an assistant teacher. By May 1913, Miriam was a militant suffragette, with keys to their offices on London

Street. In her spare time away from her job at St Paul's school she sold suffragette papers on the street. She was arrested after an empty house and a new genetics laboratory were burned down in Cambridge on 18 May, where the Norwich branch of the WSPU had been giving their support in a by-election. Suffragette leaflets were found inside both properties, along with a gold watch outside the window of the laboratory. Miriam's uncle, William Ward, who was a police constable, recognised the description of the watch as it had been a gift from him. Miriam admitted it was hers when he questioned her, and he promptly informed the authorities, and was called to give testimony against Miriam at her trial.

After being remanded for eight days Miriam was bailed, with one of the sureties of £200 being paid by Dorothy Jewson's brother, Harry. She had been suspended from her job after being arrested, so for the four months she was on bail, Miriam was employed in the Norwich Education Committee's central office. On 18 July, Miriam attended a protest demonstration held on Norwich Market Place against the Prisoners Temporary Discharge for Ill Health Act, more commonly known Cat and Mouse Act, which had come into force in March. After women and their supporters began going on hunger strike in 1908, they were subjected to the agonising and dangerous practice of forcible feeding. This caused an immense amount of outrage, but the government felt they could not allow the women to die as it would create martyrs. The Home Secretary's solution was to allow the release of a hunger striker if her life was in danger, and then recall her to prison as soon as she had recovered.

By the time that Miriam was waiting for her trial, the treatment of the suffragettes was gaining them much sympathy. In marked contrast to 1909 when their meeting was broken up, this demonstration attracted a large crowd of over 2,000. As the report from *The Suffragette* noted, 'a notable feature was the attitude of the working men, and their appreciation of the rebel spirit in the women.'

Miriam's trial began on 14 October. Despite a spirited defence which she conducted herself, she was convicted by

Mr Justice Bray at Cambridgeshire Assize Court and sentenced to eighteen months, and subsequently sacked from her job. Miriam promptly went on hunger strike, and was transferred to Holloway Prison. After five days on hunger strike, Miriam was released from Holloway Prison under the Act on a seven-day licence. She was sent to the care of friends in Kensington, with the doctor recommending three months' rest.

A few days later, a group of women interrupted a service at Norwich Cathedral, which was attended by Mr Justice Bray, by standing up and chanting the words 'Lord help and save Miriam Pratt and all those being tortured in prison for conscience sake.' As soon as they had finished, the women took their seats, but were not called upon to leave the cathedral. Printed copies of Miss Miriam Pratt's defence at the Cambridgeshire Assizes were distributed at the cathedral doors at the close of the service. Similar protests occurred elsewhere on the same Sunday, including at St Paul's Cathedral, where the protesters appealed to the church to interfere with the forcible feeding of women, while others prayed for Mary Richardson and Annie Kenney. These interrupters were ejected, and when they attempted to hold a meeting on the cathedral steps, the police intervened and arrested two of the women.

Miriam was never recalled to prison. Although various news reports stated that she disappeared, and some historical accounts claim she never returned to Norwich, she did come back and make the city her home again. Miriam was reconciled with her uncle and aunt and was living with them again when she married Bernard Francis in 1915, as well as inheriting a half share of William's property when he died in 1936. While Miriam seems to have taken a back seat in political activities after her arrest, her husband was a vocal supporter of the women's suffrage campaign, speaking against the 'torture' of the Cat and Mouse Act at the demonstration held in Norwich Market Place in July 1913. He had also become the honorary secretary of the Men's Political Union for Women's Enfranchisement. Miriam and Bernard moved to London soon after their marriage, but Miriam retained her links to Norwich and her relatives in the city until her death in 1975.

When war was declared in 1914, the WSPU suspended all political activity. In return, an amnesty was declared for the women like Miriam who had been imprisoned. However, while many suffrage campaigners followed the Pankhursts lead in putting their activities on hold, there was a significant number who did not, particularly among anti-war campaigners.

In the meantime, other local women were making their mark in local politics. One of the most notable was Mabel Clarkson (1875–1950), who became the first female councillor elected in Norwich when she won the Town Close Ward for the Liberals in 1913. As such, she joined a small but growing band of women, and by the summer of 1914 there were around fifty women councillors in England and Wales.

Mabel was youngest daughter of seven children of Richard and Elizabeth Ann Clarkson (née Prince). Her father was a solicitor who was born in Norfolk, but who moved to Calne in Wiltshire where Mabel was born. He was a strong supporter of the Liberal Party, although any direct influence on Mabel's politics can only have been minimal as he died when she was only 2½ years old. Mabel's passion for improving the lives of those less fortunate than her was largely driven by her religious beliefs. Her whole family were devout, with two of her sisters marrying clergymen, and her mother and siblings also taking a keen interest in politics and social reform.

Mabel was educated at a private school in Reading. By 1901 she was living with her widowed mother and a sister in Suffolk, where her brother lived, and two of her sisters had settled after marriage. They moved to Norwich in around 1903, and the following year Mabel was elected to the Norwich Board of Poor Law Guardians for the Ber Street Ward as a Liberal. She became one of the city's first female magistrates when she was appointed as a Justice of the Peace in 1922. She continued to serve on the Poor Law Board until 1925, during which time she lobbied the council to offer classes in laundry and cooking to unemployed factory girls to improve their chances of finding domestic work.

Mabel joined Norwich's distress committee in 1911, which managed to provide some work to the unemployed by creating

Wensum Park on the site of a former rubbish dump, a scheme repeated in the 1930s with Eaton Park. She did, however, have to defend their efforts when Dorothy Jewson and her brother published their survey into the poor of Norwich the following year, which criticised the relief given to the poor by the Poor Law Board, with Mabel declaring their report as unfair, inaccurate and exaggerated.

Nevertheless, Mabel was concerned over the lack of facilities for unemployed women and was instrumental in getting clothing workshops set up, as well as starting cookery and laundry classes for around 200 unemployed factory girls, which enabled them to become domestic servants.

Mabel's election address highlighted the effects of overcrowding on infant mortality, and public health generally when she stated that 'the best wealth of a city is in the health of its citizens'. After her election in 1913, Mabel focused much of her efforts on campaigning to improve the health of residents, including providing free school meals for needy children, a living wage and decent pensions. She gradually became more progressive, especially over housing issues as she highlighted the disgraceful conditions of some of the dwellings in the city. Having originally argued that the council's responsibilities were restricted to forcing landlords to make repairs, she moved on to suggesting the council bought and renovated properties, then began lobbying for the building of council houses while drawing their attention to the terrible conditions endured by families living in overcrowded and insanitary accommodation within the shadow of the cathedral itself.

Mabel lost her council seat in 1923. However, in 1925, she joined the Labour Party, as she felt its philosophy fitted best with what she wanted to achieve, and was re-elected for the Heigham Ward in 1926. She was elected the first female sheriff of Norwich in 1928, and was still the only woman to have served in that office in the city when she died twenty-two years later. She became the city's second female lord mayor in 1930. When the news was announced, *The Vote* paid tribute to her attention to detail, tireless energy and patience, as well as how she spared herself nothing when trying the improve the lives of those suffering

hardship: 'Even Miss Clarkson's political opponents admit how great an asset her work is to the municipal life of the city.'

In 1931, Mabel was made a CBE for her services, and served as ward alderman (*sic*) for the Fye Bridge ward between 1932 and 1948, when she was the only woman who held that position. She retired from public service in 1948 and died two years later. A glimpse of her character occurs in a report in the *Yarmouth Independent* of 21 November 1925, in which Mabel was described as having a 'fine mind'.

In February 1918, female ratepayers over the age of 30 and women married to ratepayers, were granted the right to vote in parliamentary elections for the first time. In Norwich, the majority of women could still not do so. For instance, not one woman from Globe Yard was listed on an electoral register until after 1928. Even then, very few appeared compared to the number of households and men living at the yard. Nevertheless, there were more political successes for Norwich women. There were five women on the council by 1921, including Mrs Henderson whose husband was already a councillor, so becoming the first married couple in Britain to serve on a council together. Mrs Henderson had long been involved with the Women's Labour League and had previously been elected as a Poor Law Guardian. She had also worked closely with Dorothy Jewson in 1912 on the survey into how the poor lived.

The most prominent women in Norwich politics in the early part of the twentieth century were the Colman sisters: Laura, Ethel and Helen. They were the daughters of Jeremiah James Colman of Colman's Mustard. All three women supported women's suffrage, although they never joined the suffragettes. When a meeting of the National Union of Women's Suffrage Societies was held in Norwich in February 1909, they were unable to attend, but sent letters all expressing their sympathy with the movement. It was decided to form a Norwich branch with Laura as president, and Ethel and Helen as vice presidents.

Laura Colman (1859–1920) had been to Cambridge University and married James Stuart, a professor of mathematics. She was one of the first group of women to be elected to the city council, but also became involved with many other good causes. Her

major interests included becoming a secretary for the Norwich branch of the Royal Society for the Prevention of Cruelty to Animals, a member of the Council of British and Foreign Schools Society, and was the first woman to become a deacon at her local chapel.

During the First World War, Laura was secretary of the Norfolk and Norwich Branch of the Voluntary War Work Association, for which she received an OBE. Laura was appointed as a Justice of the Peace in 1920, only a year after women were first appointed, but died only two months afterwards. One of her lasting memorials is the James Stuart garden and bowling green on Recorder Road, which was established after her death on land she bought for that purpose as a memorial to her husband. Laura's many endeavours were succinctly summed up in a tribute in the *Diss Express* on 2 November 1920, in which she was described as 'the prominent woman suffrage and social worker'.

Neither Ethel nor Helen Colman went to university, but did attend lectures at the Norwich branch of the University Extension Movement. Both put their talents to use in support of the Liberal Party, and a myriad of philanthropic enterprises in Norwich and Norfolk. Ethel Colman (1863–1948) became the first female lord mayor when she was elected in Norwich in 1923. There was no precedent as to what a woman lord mayor should be called, and as the wives of male lord mayors were traditionally known as the mayoress, Ethel Colman, and the female lord mayors who came after her, became known as lady lord mayors.

Ethel's election also marked two more firsts for women in Norwich as she chose her sister, Helen Caroline (1865–1898), to be her consort as lady mayoress, thereby becoming the first pair of women, and set of sisters, to serve in that office. Both women were active in various organisations devoted to improving the lot of the poor and needy. She was also a director of a missionary society, and one of the first women deacons at a Congregational church. Ethel and Helen also joined the non-militant National Union of Women's Suffrage Societies, becoming vice presidents of the Norwich branch in 1909, although they were averse to militant action.

After her term as lord mayor was over, Ethel continued to be involved in local politics and working to improve the lives of people in the city. In 1927, she was appointed deputy mayor to the city's first Labour lord mayor, Herbert Edward Witard. She also became one of the first women to join the prestigious Festival Committee when the Norwich Triennial Music Festival was revived.

Norwich's greatest success in the political arena in this era was the election of Dorothy Jewson (1884–1964) as a Labour MP in 1923. At the same time, she became the first female MP for the whole of East Anglia and the seventh in the UK. It was a momentous year; her election took place in the same year that Ethel Colman became the first female lord mayor anywhere in the country. Dorothy was born in Norwich into a well-known local family, who were actively involved in supporting the Liberals.

She was educated at Norwich High School for Girls, before going on to Cheltenham College and Girton College, Cambridge. During her time at Girton she became involved in the Fabian Society. She later joined the Independent Labour Party. Dorothy trained as a teacher after college and, after her return to Norwich in 1911, joined the Norwich branch of the WSPU, where she lent practical support to militant suffragettes such as Miriam Pratt, whose bail she and her brother paid after Miriam's arrest.

Dorothy was also a pacifist and joined the Society of Friends during the First World War. Her vocal opposition to the war created conflict within her own family. Her brother Harry, to whom she was particularly close, and who had supported her suffrage campaign and worked with her on instigating as survey of Norwich's poor, enlisted and was later killed. Her brother John felt that her views were treacherous, and would never see or speak to her again.

During the war, Dorothy helped establish a toy-making workshop for unemployed girls, before going on to become a full-time worker in the women's trade union movement. After the war she continued her political activities. When she stood for election in 1923, she stressed her commitment towards maintaining peace and alleviating poverty. Although Dorothy

Dorothy Jewson's election address. 1923

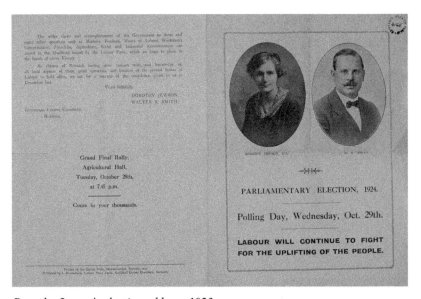

Dorothy Jewson's election address. 1923

only held her seat as an MP for a year, she never stopped supporting the causes she believed in, and went on to serve as a city councillor for seven years. She devoted her life to improving the lives of the poor, in particular women and children. As has been seen elsewhere in this book, she played an active role in drawing attention to the terrible housing conditions that thousands endured, as well as campaigning for free and safe access to birth control.

Dorothy Jewson electioneering in November 1923

The involvement of Norwich women in public life obviously did not end after the First World War. It was 1928 before all women could vote on the same basis as men, and there were, as already seen, many battles to improve healthcare, better housing and maternity provision, as well as equality in the law in the years up to the Second World War and immediately afterwards.

However, when Mabel Clarkson died in 1950, the lives, work, living conditions, housing, health, and political and legal rights of the thousands of 'ordinary' women who had lived at Globe Yard and elsewhere in Norwich had been transformed. In all aspects of public life as active citizens Norwich women epitomised the slogan 'Deeds not Words'. The world was a better place because of them.

General Timeline 1850 to 1950

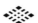

Date	Event
1851	A petition for female suffrage is presented to the House of Lords by the Sheffield Female Political Association.
1853	The Act for the Better Prevention and Punishment of Aggravated Assaults upon Women and Children increased penalties and allows third-party complaints.
1858	Divorce Act comes into force, which makes it possible to obtain a divorce without a private Act of Parliament.
1864	Contagious Diseases Act to combat venereal disease introduces compulsory health checks for women suspected of prostitution in port and garrison towns.
1865	Elizabeth Garrett becomes the first English woman to be included on the Medical Register.
1866	The first mass women's petition is presented to the House of Commons and the national campaign for Women's Suffrage begins. Another Contagious Diseases Act is introduced to combat venereal disease.
1867	Male suffrage extended. First national societies for women's suffrage hold meetings and form a loose federation of the National Society for Women's Suffrage (NSWS).
1868	Legal case over the extension of the franchise establishes that women do not vote for an MP.
1869	An amendment to the Municipal Franchise Act enables women ratepayers in England and Wales to vote in municipal council elections, but an 1872 judgement restricts the franchise to single and widowed women.

1870 Married Women's Property Act allows women to own property and keep their wages.
 An Education Act introduces school boards, which becomes the first public office that women could be elected to.
1873 Infant Custody Act allows mothers to be granted custody of children up to age 16.
1874 Married Women's Property Act passed,
 Women's Protective and Provident League is founded – later renamed the Women's Trade Union League.
1875 First woman elected as a Poor Law Guardian, but continuing confusion about whether it was legal for women to stand.
1876 All medical licencing bodies in the UK forced to open their examinations to women, but at their discretion.
1878 Matrimonial Causes Act enables women to gain some protection from abusive husbands and be granted a judicial separation.
1882 Married Women's Property Act comes into force, giving women full rights to their own property and to write a will without their husband's consent.
1886 Guardianship of Infants Acts allows women to be the legal guardians of their own children after a husband's death.
 Married Women's Maintenance Act means women are entitled to maintenance if deserted.
1888 Women able to vote in county council elections.
1894 Local Government Act enabled married and single women ratepayers to vote in county and borough elections. It also abolished the property qualification for standing for election to Poor Law Boards, meaning more women were able to.
1897 Founding of the National Union of Women's Suffrage Societies (NUWSS) by Millicent Fawcett.
1903 Founding of the Women's Social and Political Union (WSPU) by the Pankhursts – later nicknamed the suffragettes.
1905 The suffragettes adopt the slogan 'Deeds, not words' and their militant campaign begins.
1907 Qualification of Women Act enables women to sit as councillors, aldermen, mayors and chairmen on county and borough councils.
 Deceased Wife's Sister Act allows a man to marry his dead wife's sister.

1909 Force feeding of hunger strikers introduced in English prisons in September.

1911 Many supporters of women's suffrage boycott the census and embark on window smashing and arson protests.

1913 Suffragette Emily Davison dies after throwing herself in front of the king's horse at Epsom.
The Prisoners Temporary Discharge for Ill Health Act – known as the Cat and Mouse Act – allows authorities to free sick hunger strikers from prison, then rearrest them once recovered.

1914 The Great War begins, female suffrage campaigners suspend their campaign and imprisoned suffragettes are released.

1917 Women begin to be employed on light duties behind the lines during the war.

1918 Female ratepayers over the age of 30, and those married to ratepayers granted the vote.

1919 The first UK parliamentary election in which some women can vote.
The Sex Disqualifications Removal Act formally allows women into trades and the professions.

1920 The Women's Training and Employment Committee is set up to promote employment for women and to help those affected by the war.
Women gain full membership of Oxford University.
First women jurors are sworn in.

1921 Deceased Brother's Widows Act gives women to right to marry their dead husband's brother.

1923 Legitimacy Act enables children born prior to a marriage to be re-registered as legitimate.
A new Matrimonial Causes Act makes the grounds for divorce equal between men and women.

1928 All women over 21 granted equal voting rights with men.

1929 Minimum age for marriage raised to 16.

1948 Welfare State and National Health Service established.

Sources and Bibliography

All sources used are held at the Norfolk Record Office (NRO), Norfolk Heritage Centre (NHC), The National Archives (TNA), General Registry Office (GRO) and Principal Probate Registry (PPR). Some digitised copies of records and transcripts, such as census returns, electoral registers, the 1939 register and newspapers were accessed online via the commercial genealogical websites Ancestry, Findmypast and The Genealogist. Documents from the Suffrage Collection held by the Women's Library were accessed at Findmypast.

Illustrations

The photographs of the Women of Globe Yard and Suffragettes marching on Prince of Wales Road are held by the Norfolk Heritage Centre. All other documentary images are from the Norfolk Record Office. All photographs are the author's unless otherwise stated.

All copies of old postcards are courtesy of Mike Bristow. The book on Domestic Economy and proof copy of the advertisement of Prince's Tea Rooms are courtesy of Tombland Antiquarian Bookshop. The photograph of Annie Reeves is from Sam Earl's personal collection of historical material relating to the Labour Party. The *Norwich High School for Girls Magazine* is courtesy of the school's head of history, Tom Greenwood. The photographs of Globe Yard in 1937 were taken by George Plunkett and permission to use them were granted by his son, Jonathan Plunkett.

Manuscripts and Primary Sources

1851–1911 Norwich Census Returns.

1911 Census Summary Books.

1939 Register.

British Newspaper Collection (British Library).

Norfolk Broadsheet Collection at NHC. MC 2183.

Broadsheet: Murder of Jane Field, 1851. NHC Broadsheets. 30129037775591.

Carrow Works Magazines (various). NRO.

Census Enumerators' Reports. At: Vision of Britain: http://www.visionofbritain.org.uk/census

Divorce Petition: Mary Jary Gurney and John Henry Gurney, 1859. TNA: Class J 77; Piece 20.

Electoral Registers. Norwich circa 1850–1950. At NRO, NHC, Ancestry and Findmypast.

Electrical Trades Union Norwich Branch Secretary's correspondence: Letter book, 13 November 1913–14 April 1915. NRO: SO 248/2/1/1; 4-5.

Hellesdon Hospital (formerly Norwich City Asylum) Admission Records 1846–1906. NRO: HH 18/1-5.

Independent Labour Party Souvenir of the 36th Annual Conference to be held at Norwich, Easter 1928. Courtesy of Sam Earl.

Letters to Henry John Copeman 1875–1883: Copeman Correspondence. NRO: MC 284/2.

Marriage settlement and related papers of Emily Fisher and Robert Seaman concerning property in Norwich 1839–1842. NRO: B.R.A. 2641 785x2 (MS 33592).

Marriage settlement and related papers of Emily Fisher and Robert Seaman concerning property in Norwich. NRO: BRA 2641/1.

Ministry of Reconstruction. *Report of the Women's Employment Committee*. HMSO, London, 1919.

Mottram, R.H. *Assault upon Norwich*. NRO: MC 376/290, 818x4.

Mrs Gurney's Apology (pub. Philadelphia, 1860): NRO: MC 2784/A/9; mc 2847/n2/5/1-44.

National School Admission Registers and Log-Books, 1870–1914 via Ancestry and Findmypast and at NRO (various).

News cuttings collection (selective). Norfolk Heritage Centre.

Newspapers [various] via British Newspaper Collection online at British Library and Findmypast website.

Norfolk Trade Directories, 1845–1937. At NHC and NRO.

Norwich Bomb Map, 1940–1945. NRO: ACC 2007/195.

Norwich City Engineer's Building Control Plans: NRO: N/EN/12/1/-.

Norwich Corporation City Engineer Air Raid Precaution Files. NRO: N/EN 1/139; 144–146.

Norwich High School for Girls' Magazines (Parvum in Multon). Courtesy of Tom Greenwood.

Norwich Parish Register Indexes and Transcripts at: Ancestry, FamilySearch, Findmypast, FreeREG, Norfolk Family History Society and Norfolk Transcriptions.

Norwich Parish Registers (various).

Norwich Workhouse Records: Admission and Discharge Books, Birth and Death Registers, Pauper Offence Book, 1846–1896. NRO: N/NEN

Ordnance Surveys at NRO, NHC, The National Library of Scotland and The Genealogist website.

Papers about the affair between Richard Hanbury Gurney and Mary Muskett née Jary, wife of Joseph Salisbury Muskett. NRO: MC 3243/81.

Papers of J.D. Henderson, Socialist Writer: Election address of Dorothy Jewson and W.R. Smith, Parliamentary Labour candidate for Norwich. NRO: HEN 43/104.

Photograph of Dorothy Jewson election campaigning in Norwich, Nov 1923. NRO: MC 2956/1-2.

Records of Nestlé (UK) plc's Chapelfield Factory, Norwich and of Nestlé's predecessors, A.J. Caley and Son Ltd, John Mackintosh and Sons Ltd and Rowntree Mackintosh Ltd, chocolate, cracker and mineral-water manufacturers. Home Office Factory shift orders and covering letters authorising the employment of women...NRO: BR 266/107.

Souvenir Trades Union Congress, Norwich September 1937. Courtesy of Sam Earl.

St Andrew's Hospital, Thorpe St Andrew Admission Registers circa 1850-1906. NRO: SAH 181-197

Newspapers (various dates)

Diss Express
Eastern Daily Press
Eastern Evening News
Lowestoft Journal
Norfolk Chronicle
Norfolk News
Norwich Mercury
The Suffragette
The Times
Thetford and Watton Times and People's Weekly Journal

Selective Bibliography

Articles on Norwich Training College. At: https://www. keswickhallcollege.co.uk/Articles-relating-to-Keswick-Hall/

Bennett, Bridget, (ed.), *Ripples of Dissent, Women's Stories of Marriage from the 1890s.* J. M. Dent & Sons, 1996

Brierley, Rob, *Yards and Courts of Old Norwich*, 2002, at GENUKI Norfolk page: www.origins.org.uk/genuki/NFK/ places/n/norwich/yards.shtml

Brooks, Pamela, *Norwich Street by Street* 2006

Cherry, Steven, 'Medical Care since 1750' [Ch. 11] in Rawcliffe, Carole and Wilson, Richard, Eds. *Norwich Since 1550* Hambledon and London, 2004

Clarke, Christine, 'Work and Employment' [Ch. 16] in Rawcliffe, Carole and Wilson, Richard, (eds.) *Norwich Since 1550* Hambledon and London, 2004

Colman, Helen Caroline, *Jeremiah James Colman*. Chiswick Press, 1905

Co-operative Women's Guild

Crawford, Elizabeth, *The Women's Suffrage Movement in Britain and Ireland: A Regional Survey*. Routledge, 2006

Doyle, Barry, 'Politics, 1835–1945' [Ch. 14], in Rawcliffe, Carole and Wilson, Richard, (eds.) *Norwich Since 1550* Hambledon and London, 2004

Fiske, William H., *Boulton & Paul Ltd. and the Great War* NHC

Garner, Les, *Stepping Stones to Women's Liberty: Feminist Ideas in the Women's Suffrage Movement 1900–1918*. Heinemann Educational, London, 1984

George, Ethel, *The Seventeenth Child: Memories of a Norwich Childhood (1914–1934)* Edited by Carole and Michael Blackwell. Larks Press, 2006.

Gillard, Derek, *Education in England: a history*. May 2018. At: www.educationengland.org.uk/history/timeline.html

Higginbotham, Peter, Voices from the Workhouse. Author, 2012

Hodkinson, Robert, *The Mayden Troupe: female agency behind Parliament's civil war army*, March 2019, at Lord Thomas Grey's Regiment of Foote: https://lordgreys.weebly.com/ articles-and-features/maiden-troop#

Hollis, Patricia, *Ladies Elect: Women in English Local Government 1865–1914* Clarendon Press, 1987

Inder, Pamela and Aldis, Marion, *Nine Norfolk Women: Succeeding in a 19th century man's world* Poppyland Publishing, 2013

Jakeway, Julie, 'Manifestations of Madness: A study of patients of Norfolk County Asylum 1846–1870', MA in English Local History, University of Leicester, 2010

James, Zita, (ed.) 'Within Living Memory: A Collection of Norfolk Reminiscences', Norfolk Federation of Women's Institutes Boydell Press, 1972

Jermy, Louise, *The memories of a working woman* Goose & Son, Norwich, 1934

Jolly, Emma, *My Ancestor was a Woman at War* Society of Genealogists, 2014

Mackie, Charles, *Norfolk Annals*. Vols. I & II Jarrolds, Norfolk, 1901

Meeres, Frank, *A History of Norwich* Phillimore, 2nd ed., 2016

Meeres, Frank, *Dorothy Jewson Suffragette and Socialist* Poppyland Publishing, 2014

Meeres, Frank, *Ordinary Women: Extraordinary Lives*. Poppyland Publishing, 2017

Newby, Jennifer, *Researching Women's History* Pen and Sword Books, 2011

Norwich City Council, 'Mile Cross Conservation Area Appraisal', No. 12, June 2009

Norwich Municipal Secondary Girls' School Blog. Norfolk Record Office, 28 November 2018. At: https://norfolkinworldwar1.org/tag/norwich-municipal-secondary-girls-school/

Oldfield, Sybil, *Doers of the Word: British Women Humanitarians 1900–1950* Author, 2006

Pember-Reeves, Maud, *Round About a Pound a Week* Fabian Society's Women's Group, 1913

Scrivens, Phyllida, *The Lady Lord Mayors of Norwich* Pen and Sword Books, 2018

Sperandio, Jill, 'Secondary Schooling for Girls in Norwich' in *Pioneering Education for Girls across the Globe: Advocates and Entrepreneurs, 1710–1910* Lexington Books, 2018

Townroe, Peter, 'Norwich since 1945' [Ch. 19] In: Rawcliffe, Carole and Wilson, Richard, (eds.) *Norwich Since 1550* Hambledon and London, 2004

Waller, Maureen, *The English Marriage. Tales of Love, Money and Adultery* John Murray, 2009

Waring, Sophie, 'Margaret Fountaine: a lepidopterist remembered' in *The Royal Society Journal of the History of Science*, 21 January 2015

Woollard, Matthew, Research project into the classification of domestic servants in England and Wales 1851-1951. University of Essex. At: http://privatewww.essex.ac.uk/~matthew/Papers/Woollard_ClassificationofDomesticServants.pdf

Websites

Ancestry

British History Online

British Newspaper Archive (www.britishnewspaperarchive.co.uk)

British Newspaper Collection. (At: Findmypast and the British Library.)

Commonwealth War Graves Commission (CWGC)

English Heritage

FamilySearch

Findmypast

GENUKI: Norfolk

Historical Directories

Norfolk in the First World War: Somme to Armistice (https://ww1norfolk.co.uk)

Norfolk Sources

The Genealogist
The National Archives
The Times Digital Archive, 1785–1985
Victoria County Histories
Vision of Britain Through Time
Workhouses.dot.org

Index